IMAGES of America
THE MINNEAPOLIS RIVERFRONT

On the Cover: The flour mills along the downtown riverfront propelled Minneapolis's economy during the city's first 50 years. The mills, in turn, were powered by the Falls of St. Anthony, the only true falls along entire the length of the Mississippi River. By the turn of the 20th century, these industrial concerns had made Minneapolis the milling capital of the world, a title the city would hold until the 1930s.

Images of America
THE MINNEAPOLIS RIVERFRONT

Iric Nathanson

Copyright © 2014 by Iric Nathanson
ISBN 978-1-4671-1276-5

Published by Arcadia Publishing
Charleston, South Carolina

Printed in the United States of America

Library of Congress Control Number: 2014941398

For all general information, please contact Arcadia Publishing:
Telephone 843-853-2070
Fax 843-853-0044
E-mail sales@arcadiapublishing.com
For customer service and orders:
Toll-Free 1-888-313-2665

Visit us on the Internet at www.arcadiapublishing.com

To Marlene Nathanson

CONTENTS

Acknowledgments		6
Introduction		7
1.	Early Times	9
2.	Frontier Days	19
3.	Economic Boom	31
4.	Beyond the City's Center	55
5.	The Long Slide	75
6.	The New Era	89
7.	The Riverfront in the 21st Century	107
Bibliography		127

Acknowledgments

This book would not have happened without the help of the people who pointed me in the right direction as I moved ahead with this project for Arcadia Publishing.

My friend and former neighbor Mike Till introduced me to Arcadia and the helpful people there who oversee its Images of America series.

Staff members at the local history depositories helped with the daunting task of assembling more than 180 images for this book. They included Ted Hathaway, Bailey Siers, and Gail Wolfson with Hennepin County Library Special Collections; Eric Mortenson and Jennifer Huebscher with the Minnesota Historical Society; and Susan Larson-Fleming with the Hennepin County History Museum.

More photographs and useful information came from John Anfinson with the National Park Service and Dave Sheppard with the Minneapolis Rowing Club. Carol Hanson was able to share photographs and memories of her mother, Reiko Weston, who helped launch Minneapolis's riverfront revival.

Dave Stevens with the Mill City Museum and Ann Calvert with Minneapolis Community Planning and Economic Development took time out from their busy schedules to review and comment on sections of my text.

My editor at Arcadia, Maggie Bullwinkel, kept me on task, and always did so in a pleasant and helpful way.

And finally, my wife, Marlene, cheered me along during those long hours that I spent hunched over the computer.

Introduction

With the Mississippi River flowing through its urban center, Minneapolis forged close connections to its riverfront during its early years.

The city's origins extend back to the 1850s, when it was a tiny frontier settlement hugging the banks of the river at the only true falls along the Mississippi River's entire length. The power generated by this cascading flow would serve as the city's economic engine during its first half century.

Two centuries earlier, Franciscan priest Fr. Louis Hennepin came across the falls during his exploration of the Upper Mississippi and named the raging cataract for his patron saint, St. Anthony of Padua. The ecclesiastical designation would continue to identify the falls up through modern times, but Native Americans who lived nearby called it by different names: for the Ojibway people, it was Kakabikah (severed rock), while the Dakota people knew it as Minirara (curling water) or Owahmenah (falling water).

The area around St. Anthony Falls remained the preserve of the Ojibway and the Dakota until the 1820s, when a US military outpost was built on a bluff seven miles away, overlooking the confluence of the Mississippi and Minnesota Rivers. Originally named Fort St. Anthony, the post was later renamed for one of its early commandants, Josiah Snelling. In order to supply flour and lumber for the frontier post, soldiers from Fort Snelling made their way down to the falls and built the first mills to harness the power of what was then a raging wilderness cataract.

Up through 1837, land on the west bank of the falls was part of the Fort Snelling military reservation, while land on the east bank remained under the control of the local Indian tribes. That year, a treaty with federal government forced the tribes to give up their rights to the east bank, and a land rush was soon underway.

A young civilian named Franklin Steele, who worked at the fort, received advance notice that the treaty had been ratified. Steele staked his claim on the east bank of the river overlooking the falls. He would later establish the town of St. Anthony at that site. His town encompassed a small island named for early French explorer Joseph Nicollet.

In 1855, a 28-year-old New Hampshire native named John S. Pillsbury arrived in the tiny frontier settlement. Pillsbury opened a hardware store, prospered, and soon became one of St. Anthony's leading citizens. Later, he was joined by his nephew Charles and other family members. In 1865, Charles and John purchased an interest in a small flour mill, located on the town's east bank. Renamed the Pillsbury Mill, the fledging business would later emerge as one of Minnesota's industrial giants.

Across the river, the west bank, part of the Fort Snelling reservation, was off-limits to settlement—at least officially—through the 1840s and into the early 1850s. But the off-limits designation did not deter a ragtag collection of squatters who moved on to the land along the river and built crude frame homes there.

In 1852, an act of Congress severed 26,000 acres from the fort's jurisdiction and opened it to private development. Once again, a riverfront land rush occurred, and a new community soon took shape on the Mississippi's west bank. Early settlers realized that they needed a name for their small settlement, but they opted not to identify themselves with Catholic saints as their counterparts in St. Anthony and down the river, at St. Paul, had done. Instead, they decided to create a new name that linked the Dakota term *minnehaha*, which stood for "laughing water," with the Greek word *polis*, which stood for "city." The amalgam became Minnehapolis. Later, the "h" was dropped, and the new settlement became known as Minneapolis.

Soon, a string of small mills began to appear along the west-bank riverfront. In 1855, the new community of Minneapolis was linked to its older counterpart on the east bank, St. Anthony, when a suspension bridge across the Mississippi River joined the two settlements. By now, business leaders on both sides of the Mississippi River had organized themselves to manage the waterpower generated by St. Anthony Falls. On the west side, the group included Dorilius Morrison, who would become one Minneapolis's richest men and the city's first mayor. Morrison was soon joined by a Wisconsin businessman, Cadwallader Washburn, who later built a mill that bore his name.

On the east bank, local business leaders created the St. Anthony Falls Water Power Company to develop their side of the fall. In 1869, east-siders faced a major setback when a tunnel they were building under the river collapsed. Across the river, Morrison, Washburn, and their Minneapolis Mill Company were more successful with their project, which diverted the flow of the Mississippi through a tunnel and down over a series of turbines that powered each of the mills.

In 1878, Washburn faced his own disaster when his A Mill exploded, killing 14 of his workers. Washburn moved quickly to rebuild. When his new mill open in 1880, it was the newest, most up-to-date facility of its kind anywhere in the country.

Through the late 1860s and into the 1870s, the mills on the west side had surged ahead of their counterparts on the east side in terms of their production. As a result, the new town of Minneapolis grew more rapidly than its east-bank counterpart, St. Anthony. In 1872, a state legislative act enabled Minneapolis to annex the east-bank community, and St. Anthony, as a separate corporate entity, ceased to exist.

While the newly consolidated city of Minneapolis continued to focus on its downtown riverfront, municipal annexations would extend the city's jurisdiction north along to the river to the Camden district, where a small stream known as Shingle Creek emptied into the Mississippi River. Beyond downtown as the river bent east and then south, steep wooded bluffs prompted the city's park board to build a scenic parkway, which provided views of the river gorge. One bluff overlooking the east bank had become the home of Minnesota's state university. Another, at the city's southern edge, served as the site of a state home for aged military veterans.

During the latter decades of the 19th century, Minneapolis continued to develop its milling capacity, surpassing its chief rival, St. Louis, to become the world's flour-milling capital. Milling would peak in 1918, during World War I, when 18 million barrels of flour rolled out of the mills lining the downtown riverfront.

By the mid-1930s, the city's milling industry had started a slow decline as Eastern mills, located closer to major consumer markets, were able to achieve a competitive advantage over those located in Minneapolis. As the decline continued and the mills closed, the city turned its back on its riverfront origins. By 1970, the riverfront with its abandoned mills was little more than an industrial wasteland. But the seeds of a revival had been planted only a few years earlier by two urban pioneers who restored small riverfront buildings on the east and west banks. Over the next 30 years, this revival effort continued to gain momentum. By the turn of the 21st century, the Minneapolis riverfront had been reborn as a major residential, cultural, and recreational center.

One

Early Times

St. Anthony Falls' geological history extends back more than 12,000 years. During those early times, the falls was a raging cataract more than 175 feet high, located near the site of present-day downtown St. Paul. A massive river that drained glacial Lake Agassiz, a body of water extending through what is now northern Minnesota and southern Canada, fed the prehistoric falls.

The geological formation of the falls included a top layer of hard Platteville limestone over a deep strata of soft St. Peter sandstone. As the glacial runoff surged downstream and tumbled over the falls, it eroded the sandstone and undermined the top layer of limestone. This action brought huge chunks of the limestone tumbling into the river, causing the falls to recede upstream.

By the time Father Hennepin discovered the falls in 1680, it has moved upstream to a point about a half mile below its current location. A wooden apron under the falls, converted to concrete in the 1870s, stabilized the falls and prevented its gradual drift upstream. About a quarter mile farther upstream, the limestone cap disappeared, exposing the soft sandstone to the rushing flow of the river. If the falls had continued its retreat up to that point, it would have disintegrated into a series of shallow rapids.

As St. Anthony Falls continued its gradual upstream journey, an international territorial exchange was chartering a new political course for the Upper Mississippi River basin. In the early years of the 19th century, the United States obtained a huge swath of North America from the French. This 1803 transaction, known as the Louisiana Purchase, planted the American flag on more than 830,000 square miles of largely unexplored territory west of the Mississippi River, including much of what is now the State of Minnesota.

Two years after the land sale occurred, the US government sent Lt. Zebulon Pike on a mission to explore the upper reaches of the Mississippi. Pike was instructed to locate a possible site for a military post in this newly acquired territory. In 1805, the young Army officer reached the confluence of the Minnesota and Mississippi Rivers. There, on an island that now bears his name, Pike called together local Dakota leaders and persuaded them to sign a treaty that ceded 150,000 acres of land in the Upper Mississippi River to the federal government. This land cessation enabled the government to begin constructing a military post, the first permanent white excursion into modern-day Minnesota, starting in 1819.

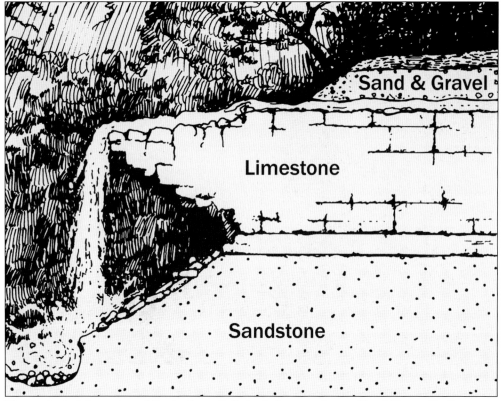

The geological formation of St. Anthony Falls includes a top layer of hard Platteville limestone over a deep strata of soft St. Peter sandstone. During the retreat of the glaciers, as the glacial runoff surged downstream and tumbled over the falls, it eroded the sandstone and undermined the top layer of limestone, causing chunks of the limestone to tumble into the river. (Courtesy of Mill City Museum.)

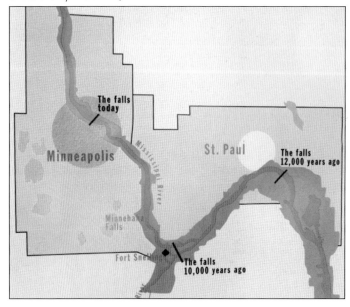

This map shows the retreat of falls over the last 10,000 years. Initially, the falls were positioned where downtown St. Paul is now located. By the 1870s, they were stabilized at their current site in downtown Minneapolis when a permanent apron was constructed under them. (Author's collection.)

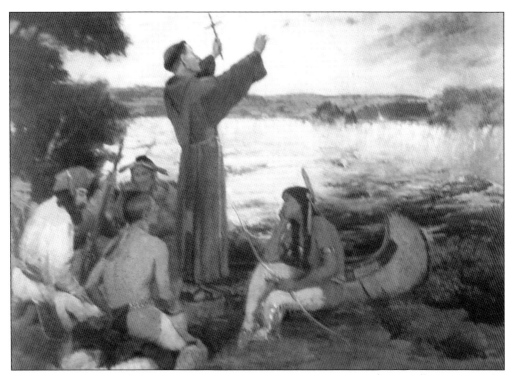

This idealized scene shows Fr. Louis Hennepin discovering St. Anthony Falls in 1680. The painting, which hangs in the Minnesota State Capitol, depicts the Franciscan cleric holding a cross at the site of the falls, while a Native American kneels beside him. In fact, the actual event was quite different from the one shown here. Father Hennepin was a captive of the Dakota when he came upon the falls during his North American explorations. (Courtesy of Minnesota Historical Society.)

After his Indian captors released him, Father Hennepin went back to Europe. He never returned to North America. His writings helped popularize St. Anthony Falls and Niagara Falls, which he also visited during his explorations. The adventurous priest lent his name to a variety of locations in Minnesota, including one of Minneapolis's major thoroughfares and the state's largest county. (Courtesy of Hennepin County Public Library Special Collections.)

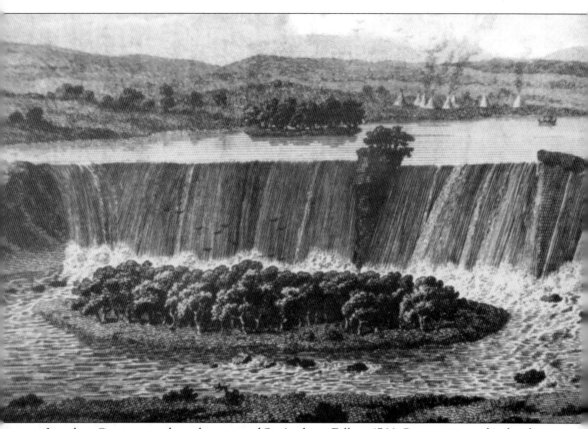

Jonathan Carver, an early explorer, visited St. Anthony Falls in 1766. Carver estimated its height at 29 feet. He later wrote that the rapids below the falls "render the descent considerably greater; so that when viewed from a distance they appear much higher than they really are." This illustration is the first-known image of the falls as they actually were during those early times. (Courtesy of Minnesota Historical Society.)

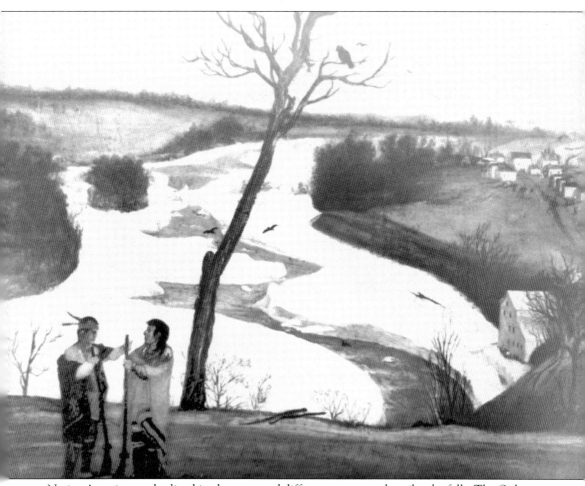

Native Americans who lived in the area used different names to describe the falls. The Ojibway people called it Kakabikah (severed rock), while the Dakota knew it as Minirara (curling water) or Owahmenah (falling water). Through a series of treaties, they would eventually give up their rights to live freely in the land along the Upper Mississippi River. (Courtesy of Minnesota Historical Society.)

In 1805, the US Army sent Lt. Zebulon Pike on an expedition to secure the site for a military post on the upper reaches of the Mississippi River, in land acquired from the French through the Louisiana Purchase. When he reached the confluence of the Mississippi River and what is now the Minnesota River, Pike called together the local Indian tribes and negotiated a treaty that gave the US government the right build a fort at the site. (Courtesy of Hennepin County Public Library Special Collections.)

On the morning of September 23, 1805, Zebulon Pike met with a group of Dakota chiefs on an island at the confluence of the two rivers, where he negotiated the first land cession in Minnesota. The island, which now bears his name, was later the site of the internment of Dakota people following the US-Dakota War of 1862. This photograph shows Pike Island in 1895. (Courtesy of Hennepin County Public Library Special Collections.)

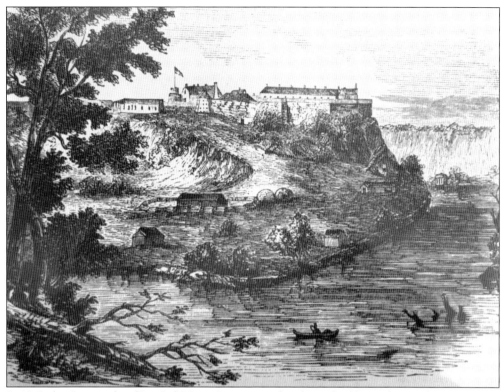

In 1819, the Army ordered Lt. Col. Henry Leavenworth to begin building a fort on the site secured by Zebulon Pike 14 years earlier. The military outpost was intended to bring an American presence into the Upper Mississippi River basin. The fort, perched on a strategic bluff overlooking the Mississippi River, became the first permanent white settlement in what later became the state of Minnesota. (Courtesy of Minnesota Historical Society.)

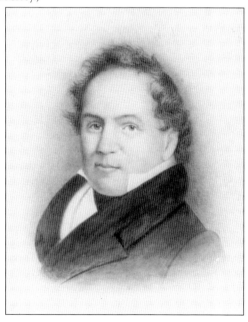

Only a year after he arrived at the fort site, Leavenworth was replaced by Col. Josiah Snelling. Snelling presided over the frontier military outpost during its early years of development in 1820s. The fort would later be named for him. In the 20th century, Fort Snelling would become one of Minnesota's most popular historic sites. (Courtesy of Hennepin County Public Library Special Collections.)

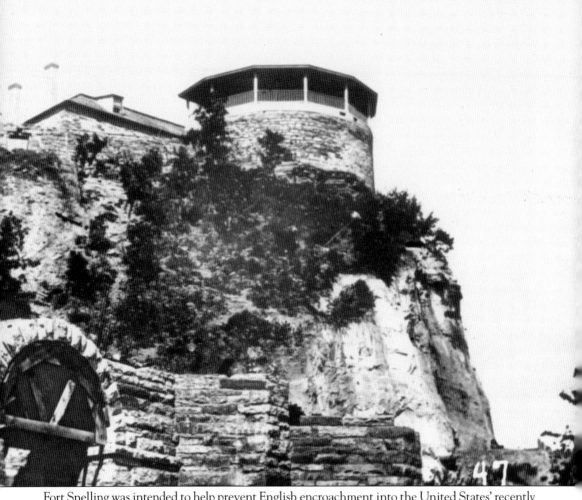

Fort Snelling was intended to help prevent English encroachment into the United States' recently acquired Northwest Territory. The fort's strategic location at the confluence of the Mississippi and Minnesota Rivers gave the US Army control over river traffic in the Upper Mississippi River basin. (Courtesy of Hennepin County Public Library Special Collections.)

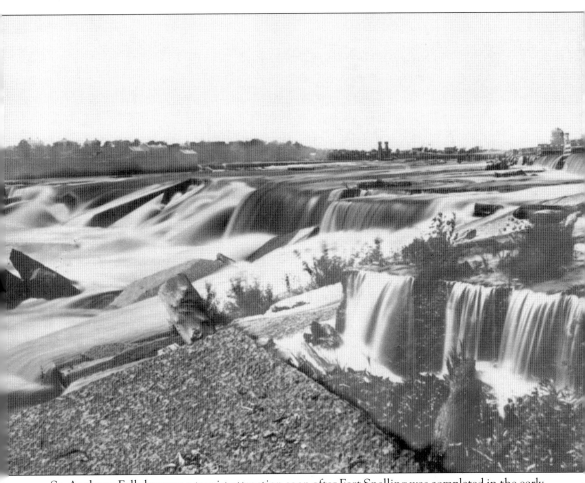

St. Anthony Falls became a tourist attraction soon after Fort Snelling was completed in the early 1820s. Steamboats travelling up the Mississippi River brought visitors to the newly established military post, where they began an overland journey to the falls. An early visitor, Count Giacomo Beltrami, marveled at the falls' "magic play of light and shadows" and its "white foam and glittering spray." (Courtesy of Hennepin County Public Library Special Collections.)

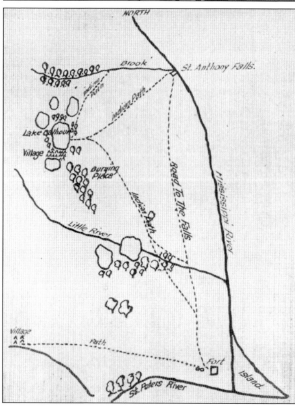

In order to make his fort self-sufficient, Colonel Snelling established a farm at the military site. At St. Anthony Falls, his soldiers built a gristmill to grind wheat grown at the fort and a sawmill to produce lumber from the timber harvested there. Snelling later wrote that his soldiers had sawed over 3,000 feet of pine planks at the mill in a 24-hour period. (Courtesy of Hennepin County Public Library Special Collections.)

Soldiers from the fort reached St. Anthony Falls, seven miles away, by travelling overland along a trail that connected the two sites. The trail later became the route of a major Minneapolis thoroughfare linking the downtown riverfront to the military post, now operated as an interpretive center by the Minnesota Historical Society. (Courtesy of Hennepin County Public Library Special Collections.)

Two

Frontier Days

Soon after Fort Snelling was established in the 1820s, steamboats travelling up the Mississippi River brought visitors to the new frontier military outpost. Many of these early tourists took the overland route to St. Anthony Falls, seven miles away. Soon, the falls became a major tourist attraction, drawing throngs of visitors travelling upriver to the escape the South's summer heat.

Military leaders at Fort Snelling had more prosaic concerns. As early as 1819, the fort's first commandant, Lt. Col. Henry Leavenworth, urged his superiors in Washington, DC, to authorize construction of a sawmill and a gristmill at the falls. When that authorization was granted, Leavenworth's successor, Col. Josiah Snelling, oversaw the construction of the mills and two nearby military barracks on the falls' west bank.

By the 1830s, the falls had become more than a tourist attraction and the site of two small government mills. Eastern speculators were starting to eye what they viewed as a prime piece of frontier property with great economic potential. The fever of land speculation reached into the fort itself, where one of its officers, Maj. Joseph Plympton, hoped to personally benefit by staking a riverfront claim once the land was opened to private ownership.

Plympton knew that potential developers could obtain ownership rights by demonstrating that they had settled on a site—usually by doing nothing more than building a flimsy shack there. Plympton also knew that if he could lay claim to property adjacent to the falls, he would be able to help control the waterpower generated by the falls, through a common law doctrine known as riparian rights.

The Army major hoped to claim a prime east-bank site once word reached the fort that the treaty with local Indian tribes, opening the east bank to development, had been ratified in Washington. According to local lore, when he learned that the treaty had been ratified, Plympton raced down to the falls on a July morning in 1838. But, he found that someone else had gotten there first. The fort's storekeeper, 28-year-old Franklin Steele, had received advance notice of the treaty ratification and staked his own claim the night before Plympton arrived.

Steele's claim helped launch his new career as one of Minnesota's early riverfront developers. He would go on to organize the fledgling community of St. Anthony and play a key role in harnessing the economic potential of the falls that lent its name to Steele's new town.

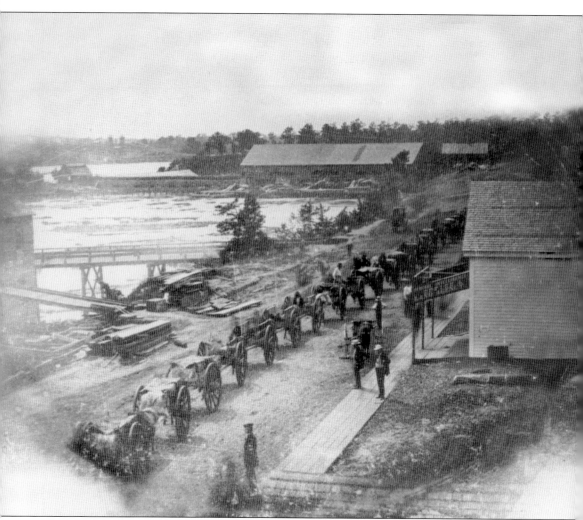

The Metis, people of mixed European and Indian background, drove their carts down to the St. Anthony from their homes near the Canadian–United States border. They were traders who brought furs and pelts down to the falls in exchange for goods that they brought back up north. (Courtesy of Hennepin County Public Library Special Collections.)

Franklin Steele was an ambitious 25-year-old civilian storekeeper at Fort Snelling when he decided to seek his fortune as a real estate developer. Steele's early claim to a prime piece of property at St. Anthony Falls gave him a head start in the land rush that occurred when the area was opened to white settlement in the 1830s. It would take Steele nearly 10 years to amass enough capital to undertake his first development, a dam and sawmill at the falls. (Courtesy of Hennepin County Public Library Special Collections.)

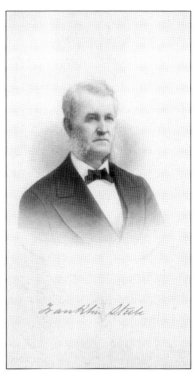

Many of St. Anthony's early settlers were native New Englanders with ties to that region's lumber industry. "At first glance," observed one local historian, "early St. Anthony resembled a New England village with white houses surrounded by gardens . . . giving easterners the feeling that they had found . . . a bit of home transported to the falls." But, a second look revealed that St. Anthony during its early days was a rough frontier settlement with few urban refinements. (Courtesy of Hennepin County Public Library Special Collections.)

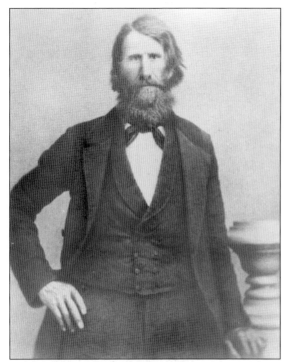

Ard Godfrey, a Maine millwright, moved to St. Anthony in the late 1840s to help develop the town's fledgling sawmill industry. Initially, he partnered with Franklin Steele to operate the St. Anthony Mill Company, which provided milling services on a contract basis for local lumbermen. Godfrey also served as the first postmaster of the village of St. Anthony. His Greek Revival home became an important historic landmark. (Courtesy of Hennepin County Public Library Special Collections.)

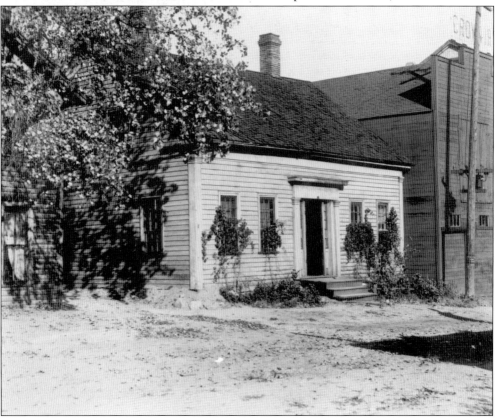

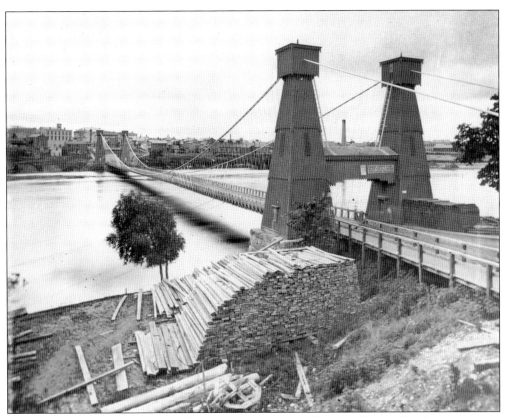

Civic leaders from Minneapolis and St. Anthony came together to endorse a plan for a suspension bridge connecting the two riverfront communities. When the bridge opened to traffic in 1855, it was the first span to cross the Mississippi River at any point along its entire 2,300-mile length. A local observer described the structure as "one of the most elegant, tasteful, and substantial works of art in the West." (Courtesy of Hennepin County Public Library Special Collections.)

The bridge, which opened in January 1855, was supported with tolls. The toll master, Capt. John Trotter, collected 15¢ for a horse, 10¢ for a cow, 2¢ for a sheep, and 3¢ to 5¢ for a person. The first suspension bridge continued to connect the east and west banks until it was replaced by a new bridge in 1875. (Courtesy of Hennepin County Public Library Special Collections.)

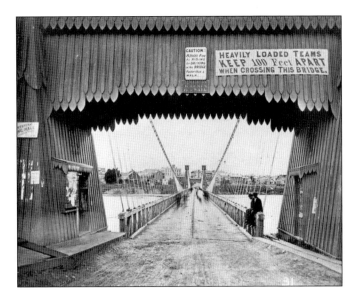

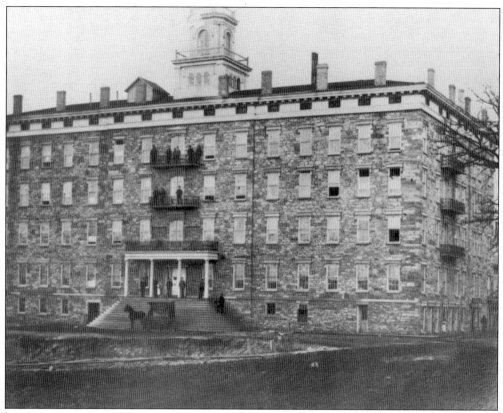

In 1857, a large five-story hotel, topped by an imposing cupola, was built on an east-bank bluff facing the falls. Known as the Winslow House, the hotel attracted guests from the river towns all along the southern reaches of the Mississippi River. For many of these guests, a visit to the Winslow House was a way to escape the oppressive summer heat in the South. (Courtesy of Hennepin County Public Library Special Collections.)

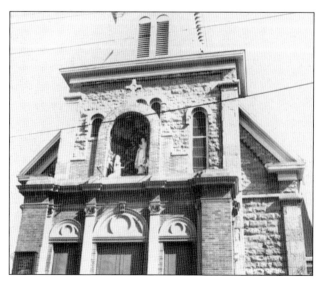

In the mid-1850s, the First Universalist Society built a church on the east bank overlooking St. Anthony Falls. Renamed Our Lady of Lourdes, French Canadian Catholics purchased the church in 1877. After the building was converted from a Universalist to a Catholic church, a tower and statuary over the front entrance were added. As the oldest house of worship in continuous use in Minneapolis, Our Lady of Lourdes Church would become an important riverfront landmark. (Courtesy of Hennepin County Public Library Special Collections.)

While the west bank of the Mississippi River was still part of the Fort Snelling reservation, John H. Stevens received permission from the War Department to build a home there in exchange for providing ferry service across the river. During the winter of 1849–1850, Stevens built the first permanent home in what would later become the city of Minneapolis. Soon after Minnesota became a state in 1858, Stevens was elected to the Minnesota House of Representatives and later to the Minnesota Senate. (Courtesy of Hennepin County Public Library Special Collections.)

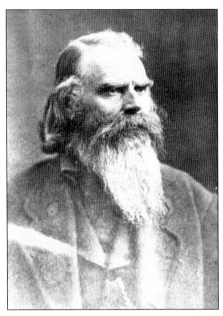

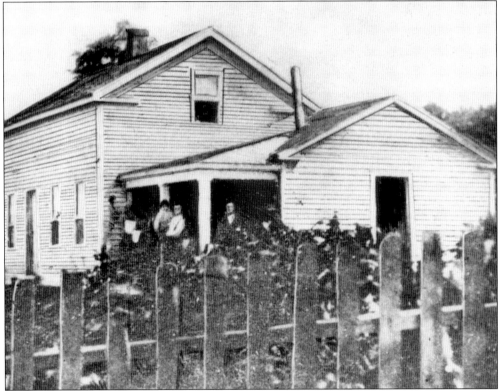

The Stevens home served as the political and social center for the tiny community of Minneapolis during its early years. Community leaders gathered there to name the city and to establish the legal framework for the area's municipal and county governments. Church services and weddings were conducted in the Stevens home, and federal judges presided over territorial courts that were held there. (Courtesy of Hennepin County Public Library Special Collections.)

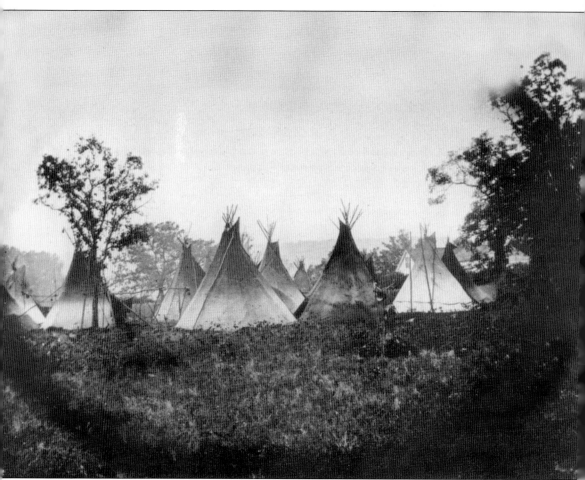

When John H. Stevens built a home on the west bank of the river in the late 1840s, the area was still a frontier wilderness. Native Americans often camped nearby. Stevens later remarked, "We have often gone to bed at night . . . waked up and seen that while we were asleep, the wigwams of the Sioux, Chippewa, or Winnebago had gone up. They thought they had a right to be our guests. As long as they treated us properly, we had no disposition to dispute those thoughts." (Courtesy of Hennepin County Public Library Special Collections.)

It took a while for the west-side settlers at St. Anthony Falls to decide on a name for their new community. Lowell was one suggestion, after Lowell, Massachusetts, where the town's industries were also powered by falls. Albion, West St. Anthony, and All Saints were also proposed. In the end, the early residents settled on Minneapolis, which combined *minnehaha*, the Dakota word for "laughing waters," with *polis*, the Greek word for "city." (Courtesy of Hennepin County Public Library Special Collections.)

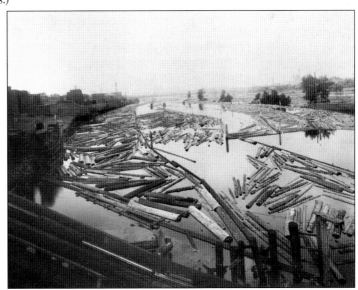

The timber harvested in the northern Minnesota forests fed Minneapolis's lumber industry. The logs were floated down the Mississippi River to the sawmills lining the river above the falls. Boom Island was used as a sorting station for the floating timber as it was being prepared for processing at the local sawmills. (Courtesy of Hennepin County Public Library Special Collections.)

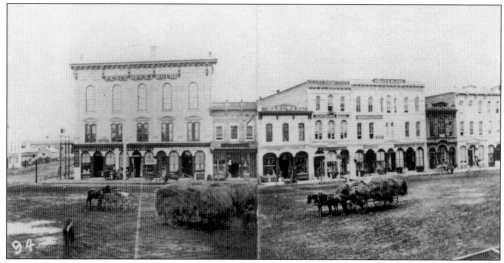

Bridge Square, located at the southern end of the Hennepin Avenue Bridge, became the center of civic and political life during Minneapolis's early years. The community's early city hall was built on a triangular plot of land facing the square, where Nicollet and Hennepin Avenues intersected. (Courtesy of Hennepin County Public Library Special Collections.)

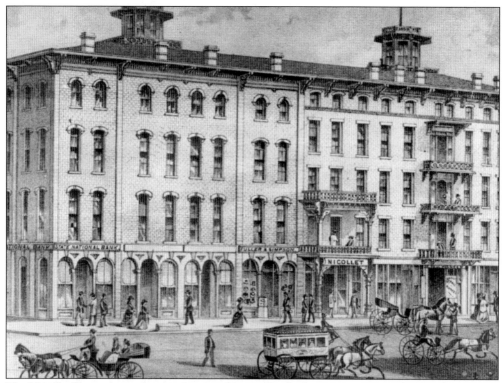

The Nicollet House, located across the river from its St. Anthony counterpart, the Winslow House, became the place to stay in Minneapolis when the hotel opened in 1858. It was decorated with lace curtains, mirrored parlors, and plush furniture, adding a touch of elegance to the frontier community. (Courtesy of Hennepin County Public Library Special Collections.)

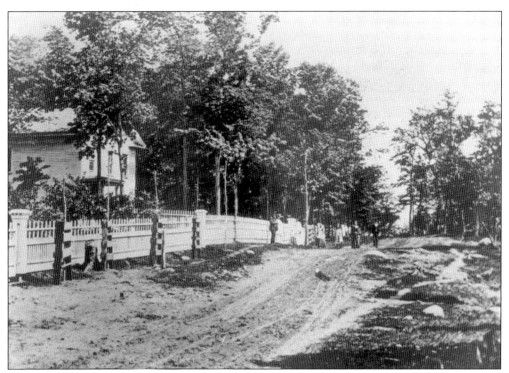

Just a little under a square mile in size, Nicollet Island is one of the few inhabited islands on the Mississippi River. Franklin Steele was able to purchase prime sections of the island soon after he staked his east-bank claim in 1838. Early residents commented on the bucolic nature of the heavily wooded island, located just above St. Anthony Falls. (Courtesy of Hennepin County Public Library Special Collections.)

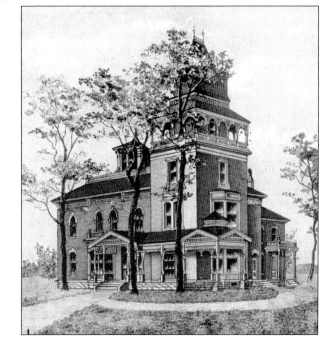

During the mid-19th century, several wealthy local families built imposing Victorian homes on the island. After the turn of the century, the island fell into a decline, as industrial uses began to crowd out the homes located there. (Courtesy of Hennepin County Public Library Special Collections.)

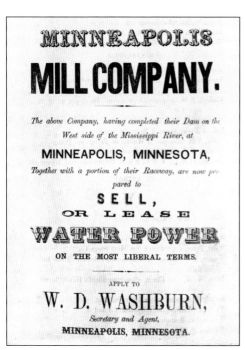

In February 1856, the Minneapolis Mill Company received a charter from the Minnesota Territorial Legislature to maintain a dam on the Mississippi River and undertake other improvements aimed at harnessing the power of the falls for the west-side mills. The territorial charter acknowledged the company's right to make use of the river flowing past its property through a doctrine known as riparian rights. (Courtesy of Hennepin County Public Library Special Collections.)

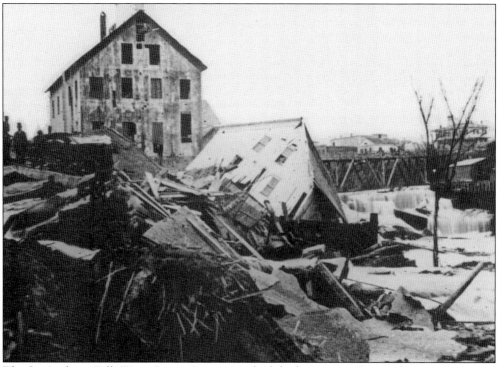

The St. Anthony Falls Water Power Company, which had riparian rights on the riverfront's east side, began constructing a tunnel under Nicollet Island in 1867. In October 1869, with 2,000 feet of the tunnel already dug, the Mississippi River broke through the construction site and threatened to wash away the falls. The 1869 tunnel collapse spurred the construction of a permanent apron under the falls. (Courtesy of Minnesota Historical Society.)

Three

Economic Boom

In 1851, a small gristmill at St. Anthony Falls began grinding flour and corn meal on a custom basis for local farmers. Then, in 1854, the first in a series of commercial or merchant mills began producing flour and marketing their products to broader markets beyond the nearby farms within easy reach of the Mississippi River.

When the river's west bank was opened for development in the mid-1850s, it soon became the location of choice for many of the area's milling pioneers. An early group of those pioneers, including Dorilius Morrison and Cadwallader Washburn, began expanding the small mills that sprang up along a stretch of riverfront, now incorporated in the new town of Minneapolis.

Over the next 30 years, new and more elaborate mills were built on both sides of the river. They included the massive Pillsbury A Mill on the east bank and its west-bank counterpart, the Washburn A Mill.

The new mills, which towered over their older neighbors, were aimed at moving the city's burgeoning milling industry to even greater heights. But, even with their larger, better-equipped facilities, the Minneapolis mill owners knew that they were being held back by the quality of the flour produced by the hard spring wheat grown in the Upper Midwest. Millers farther south, including those in St. Louis, produced flour from the softer winter wheat, which was easier to mill.

Advances in milling technology in the 1870s enabled Minneapolis millers to overcome the disadvantages of the spring wheat and substantially improve the quality of their products. By now, an expanding railroad network was bringing a flood of wheat grown on fertile Upper Midwest farmlands to the riverfront mills. These same railroads were sending Minneapolis-milled flour out to markets throughout the United States and, though the port of Duluth, to markets overseas.

The role of the railroads at the Minneapolis riverfront was symbolized by the elegantly curving Stone Arch Bridge built by Minnesota's railroad baron James J. Hill in 1883.

In 1885, the city's mills produced more 5.5 million barrels of flour, an amount large enough to supply bread for the entire population of the city of New York. Each day, nearly 270 boxcars, equivalent to a train stretching for almost two miles, supplied the wheat used by the mills to meet their production goals.

With its access to a national and international transportation system, Minneapolis surpassed St. Louis in flour-milling production to become the world's milling capital, a title it would hold for the next half century.

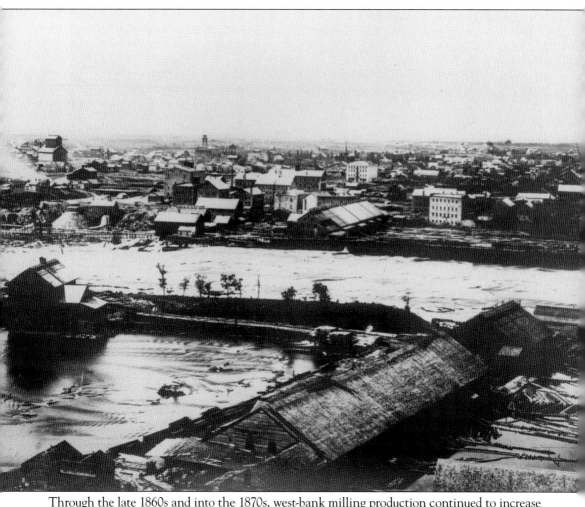

Through the late 1860s and into the 1870s, west-bank milling production continued to increase more rapidly than production on the east bank. As a result, the new town of Minneapolis grew more quickly than its east-bank counterpart St. Anthony. In 1872, a state legislative act enabled Minneapolis to annex the east-bank community, and St. Anthony, as a separate corporate entity, ceased to exist. (Courtesy of Hennepin County Public Library Special Collections.)

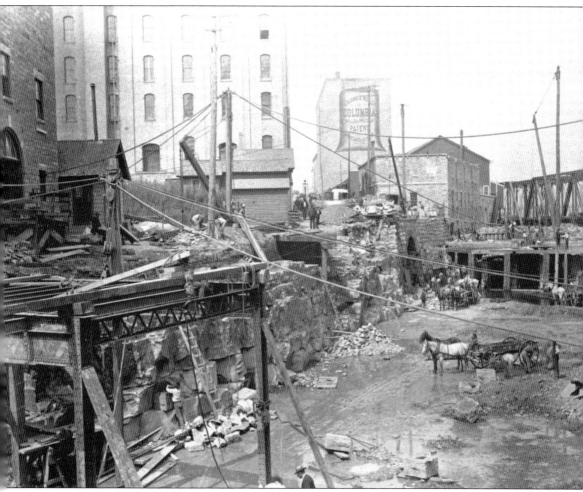

In 1857, the Minneapolis Mill Company began work on a 215-foot-long canal to channel the flow of the falls toward the west-side mills. One local historian later observed that "more than any other installation harnessing the falls, this waterway nourished young Minneapolis. Along its shores would raise the huge flour mills that would bring the city world renown." This photograph shows improvements being made to the canal in the 1890s. (Courtesy of Mill City Museum.)

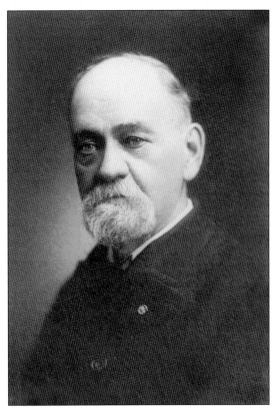

In 1855, New Hampshire native John S. Pillsbury, pictured at left, chose St. Anthony as his new home. The young New Englander was attracted by the economic potential of the town's site adjacent to St. Anthony Falls. Later, John was joined by his brother George and his nephew Charles. Together, the three men formed an early flour milling company that would later bear their family name. The Pillsbury mills would help fuel Minneapolis's economic boom during the later decades of the 19th century. (Courtesy of Hennepin County Library Special Collections.)

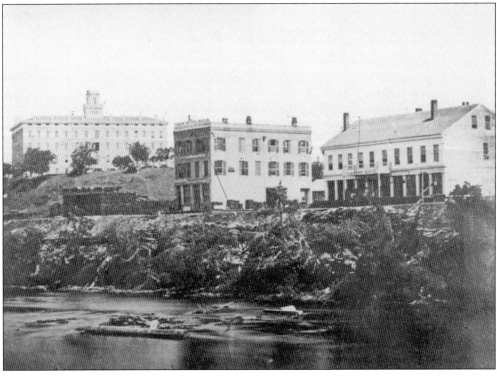

Like many of the city's early leaders, Cadwallader Washburn was a native of Maine. He left his home state in 1839 and lived for a time Iowa and Illinois before settling in Wisconsin. Washburn managed his Minnesota business interests from his Wisconsin home in LaCrosse. In addition to his flour milling interests, Washburn was actively involved in developing the waterpower generated by St. Anthony Falls. (Courtesy of Hennepin County Public Library Special Collections.)

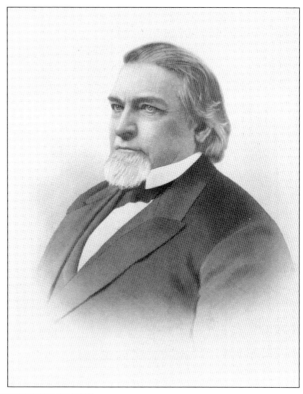

While Cadwallader Washburn remained in Wisconsin, his brother William looked after the family's business interests in Minnesota. William Washburn was a major civic and political leader, serving as a US senator from Minnesota from 1889 to 1895. His palatial estate Fair Oaks was a local showplace. Fair Oaks later became a city park located across from the Minneapolis Institute of Arts. (Courtesy of Hennepin County Public Library Special Collections.)

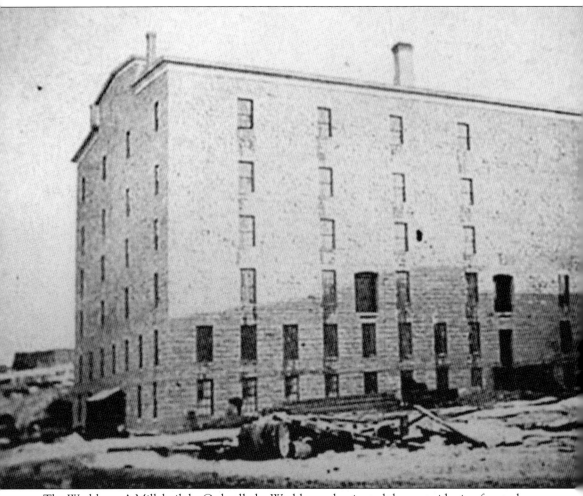

The Washburn A Mill, built by Cadwallader Washburn, dominated the west-side riverfront when it was constructed in 1874. The massive seven-story building harnessed the waterpower generated by St. Anthony Falls to operate its milling machinery. With 200 workers at its riverfront site, the Washburn mill was one of the city's largest employers. (Courtesy of Hennepin County Public Library Special Collections.)

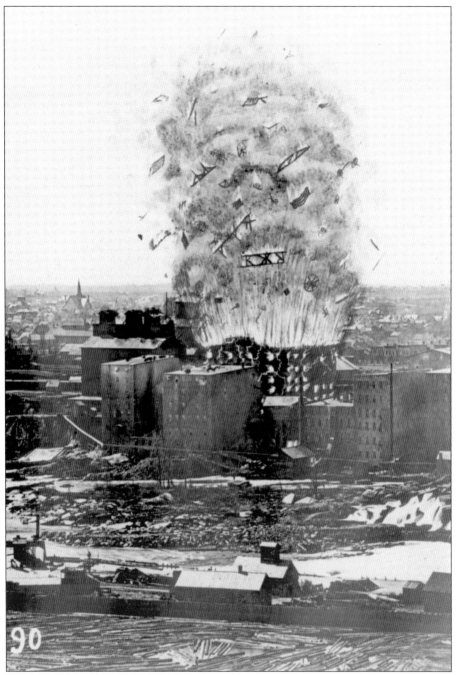

At 7:00 p.m. on the evening of May 2, 1878, the Washburn A Mill exploded in a ball of fire, killing 14 Washburn workers along with four men at the nearby Diamond and Humboldt mills. One observer reported seeing "a stream of fire" pouring out of the A Mill's basement windows. "Then each floor above the basement became brilliantly illuminated, the light appearing simultaneously at the windows as the stories ignited one above the other," he recalled. "The roof was projected into the air to great height, followed by a cloud of black smoke." (Courtesy of Hennepin County Public Library Special Collections.)

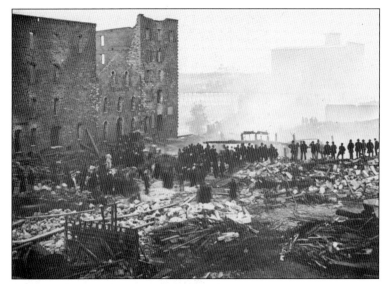

Following the explosion, the Minneapolis Fire Department worked all night in a futile effort to contain the flames. But, the intense heat blocked its rigs and hoses from getting close enough to the site to have much of an impact. (Courtesy of Hennepin County Public Library Special Collections.)

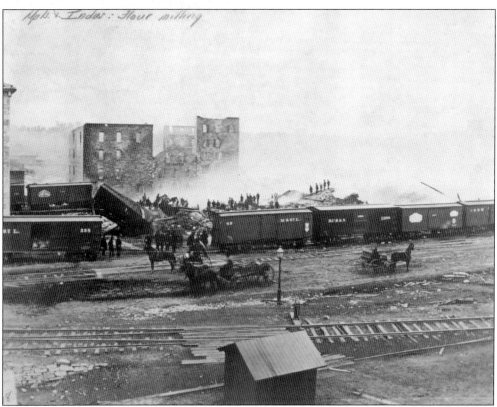

The *Minneapolis Tribune* report that "in a twinkling of an eye, by an explosion that shook the city like a rocking of an earthquake, the largest, the highest, and probably the heaviest stone structure in Minneapolis, the great Washburn mill, which has been the pride and boast of our flourishing city, was leveled to the ground. Soon the burning buildings sent their messengers of flame on the wings of the merciless north wind on to other fields of destruction." (Courtesy of Hennepin County Public Library Special Collections.)

Almost immediately, rumors began to spread about the causes of the Minneapolis disaster. In St. Paul, residents thought an earthquake had occurred. Others said they heard that a railroad car loaded with nitroglycerine had exploded in the mill district. John A. Christian, the A Mill's manager (shown here), later put the rumors to rest when he explained that the disaster had probably been caused by rapidly burning flour dust. (Courtesy of the Mill City Museum.)

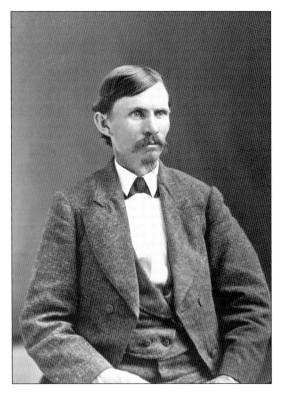

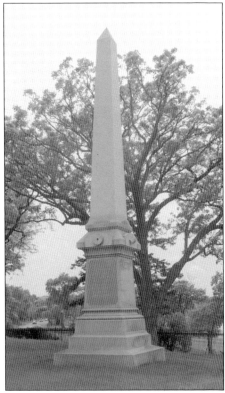

In 1885, the Minneapolis Head Millers Association erected a monument honoring the men who were killed in the milling disaster. The monument in the form of a 30-foot-tall obelisk stands at the west end of Lakewood Cemetery, overlooking Lake Calhoun. It is decorated with a broken mill wheel and a shaft of wheat. The inscription reads, "In memory of those who gave their lives in the great mill explosion of May 2, 1878." (Author's collection.)

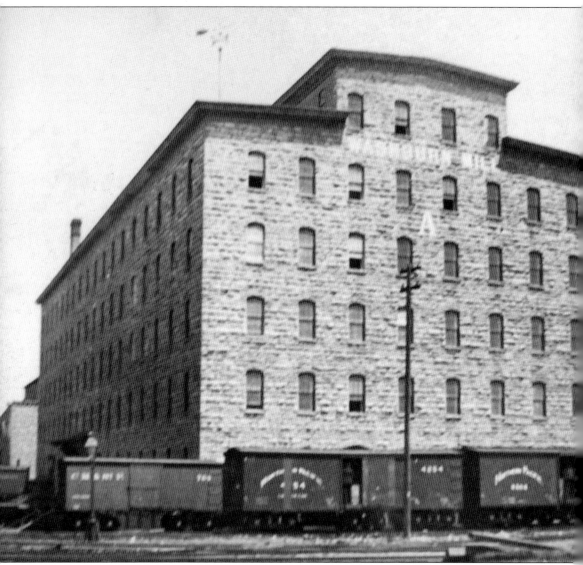

Cadwallader Washburn rushed to Minneapolis from his Wisconsin home as soon as he learned about the mill explosion. While the embers were still hot, Washburn vowed to quickly rebuild his flagship milling facility; he kept his word. By 1880, his new A Mill was up and running. It was safer and more technologically advanced than its predecessor, with an even greater production capacity. (Courtesy of Hennepin County Public Library Special Collections.)

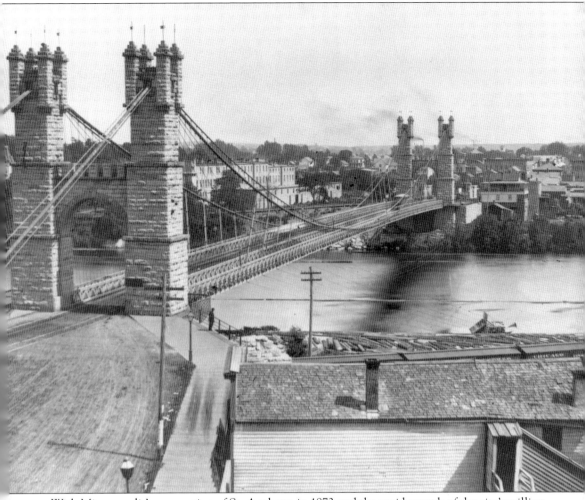

With Minneapolis's annexation of St. Anthony in 1873 and the rapid growth of the city's milling industry, civic leaders on both sides of the river realized that the 1854 suspension bridge was no longer meeting the city's needs. In 1876, a new larger Hennepin Avenue Bridge linked the east-side and west-side milling districts. The new bridge features medieval-style turrets and parapets. (Courtesy of Hennepin County Public Library Special Collections.)

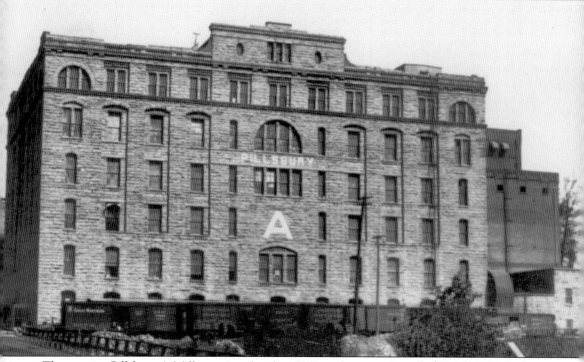

The massive Pillsbury A Mill was completed in 1881 at the cost of nearly $500,000. With the capacity to produce 4,000 barrels of flour a day, the seven-story structure would become the largest flour mill in the world. The Pillsbury A Mill would continue in operation on a limited basis up through the early years of the 21st century. (Courtesy of Hennepin County Public Library Special Collections.)

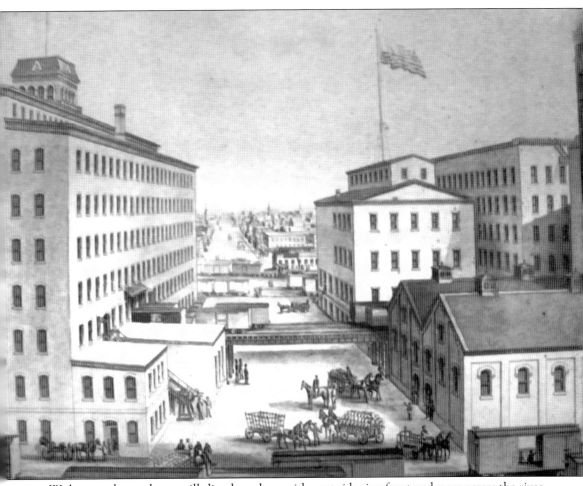

With more than a dozen mills lined up along with west-side riverfront and more across the river on the east side, the city's milling industry boomed during the later decades of the 19th century. By the end of the century, Minneapolis had surpassed St. Louis to become the flour-milling capital of the world. The milling boom helped fuel a dramatic rise in the city's population between 1880 and 1900. (Courtesy of Hennepin County Public Library Special Collections.)

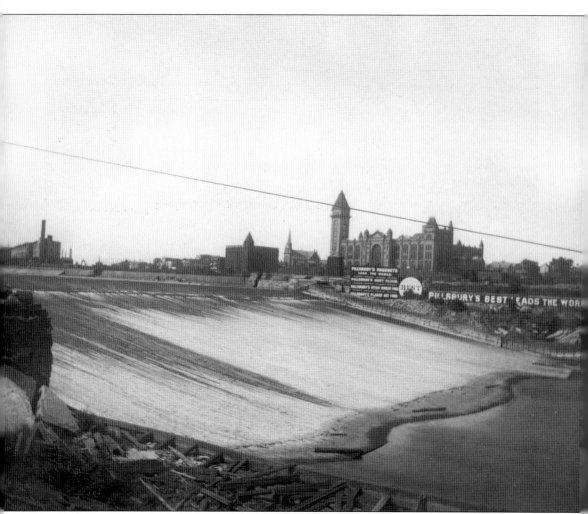

With the increasing industrialization of the Minneapolis riverfront, St. Anthony Falls was no longer the raging wilderness cataract it had been during the early decades of the 19th century. Following the river tunnel collapse in 1869, the Army Corps of Engineers built a concrete apron under St. Anthony Falls, which permanently altered its appearance. (Courtesy of Hennepin County Public Library Special Collections.)

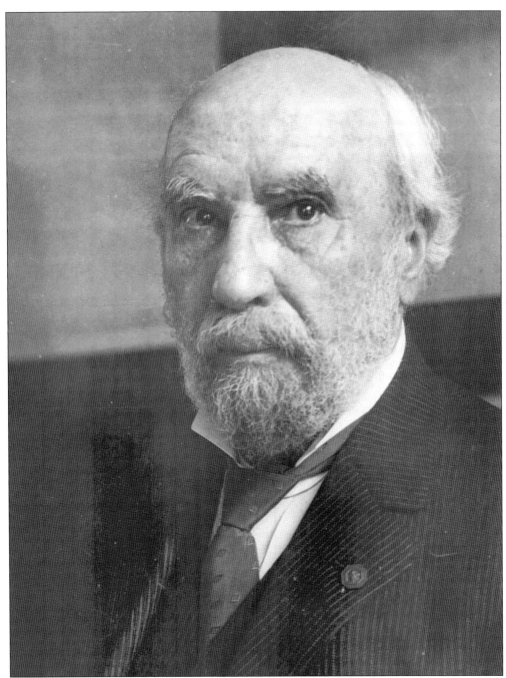
James J. Hill arrived in St. Paul, Minnesota, from his native Ontario, Canada, as a penniless 18-year-old in 1856. Over the next 30 years, he would emerge as one of Minnesota's most powerful businessmen. Known as the "Empire Builder," Hill amassed a fortune as head of the Great Northern Railroad. He also maintained a financial interest in one of the Minneapolis companies that managed the production of waterpower at St. Anthony Falls. (Courtesy of Hennepin County Public Library Special Collections.)

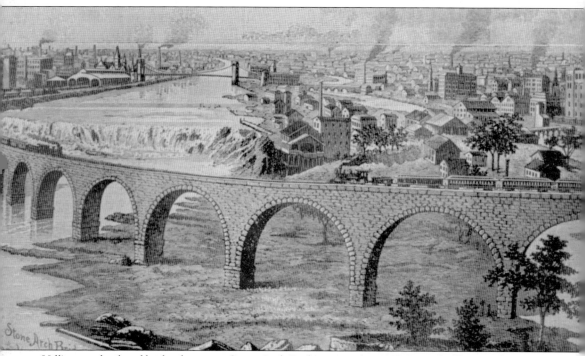

Hill's curved railroad bridge, known as Stone Arch Bridge, opened in 1883. Described by one observer as "the most poetic of all Twin Cities bridges and a spectacular feat of Victorian engineering," the 2,000-foot-long structure was the only arched bridge that spanned the Mississippi River at that time. Hill once said that building the bridge was "the hardest thing I ever had to do in my life." Trains continued to travel over the bridge until it was closed to railroad traffic in 1978. (Courtesy of Hennepin County Public Library Special Collections.)

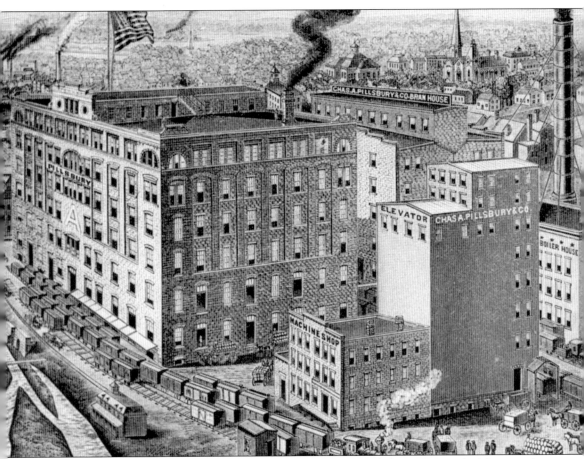

St. Anthony Falls powered the turbines in a series of mills crowded together on the Minneapolis riverfront. With advances in the milling process, which improved the quality of the flour milled locally, the city would become the country's milling capital by the 1880s. (Courtesy of Hennepin County Public Library Special Collections.)

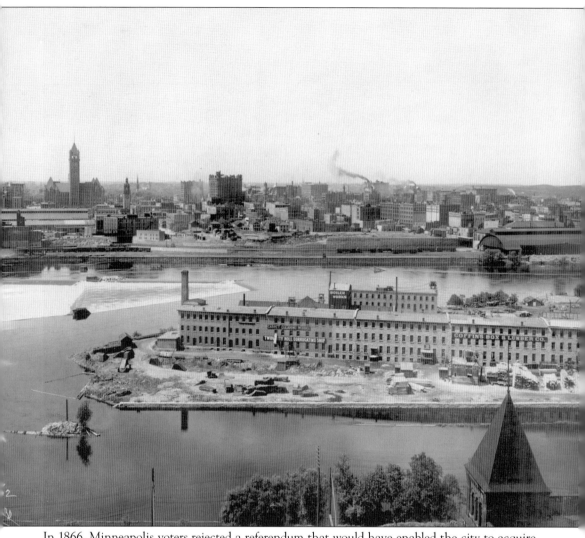

In 1866, Minneapolis voters rejected a referendum that would have enabled the city to acquire Nicollet Island and convert it to a park. Later in the 19th century, industrial development began to encroach on the southern end of island. Eventually, the island's commercial and industrial character drove away the well-to-do families that had settled there. This photograph shows a series of connected factory buildings that dominated the island's southern tip. (Courtesy of Hennepin County Public Library Special Collections.)

The Exposition Building was constructed in 1887 at an east-bank site overlooking the Mississippi River. The massive eight-story structure included a 240-foot-high tower, which could be seen all along the downtown riverfront. The building was intended to showcase modern technology and serve as a civic center. The high point in the Exposition Building's history came in 1892 when it was the site of the Republican National Convention. (Courtesy of Hennepin County Public Library Special Collections.)

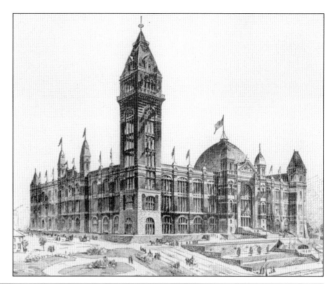

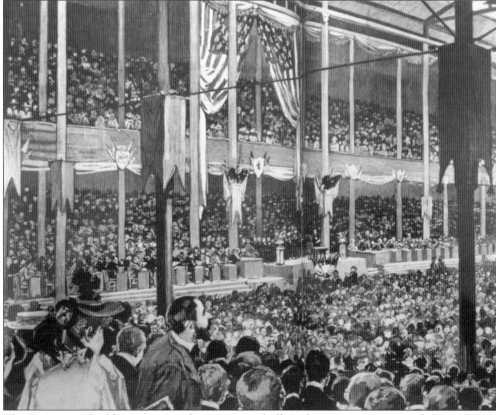

The Exposition Building's mammoth convention hall, with a seating capacity of about 12,000, was outfitted with opera chairs for the delegates who occupied the center of the hall. The *New York Times* declared that the convention hall was "the handsomest most convenient space ever provided for any political party in the country." The convention nominated the incumbent Republican president Benjamin Harrison for a second term. In November 1892, Democrat Grover Cleveland defeated Harrison. (Courtesy of the Minnesota Historical Society.)

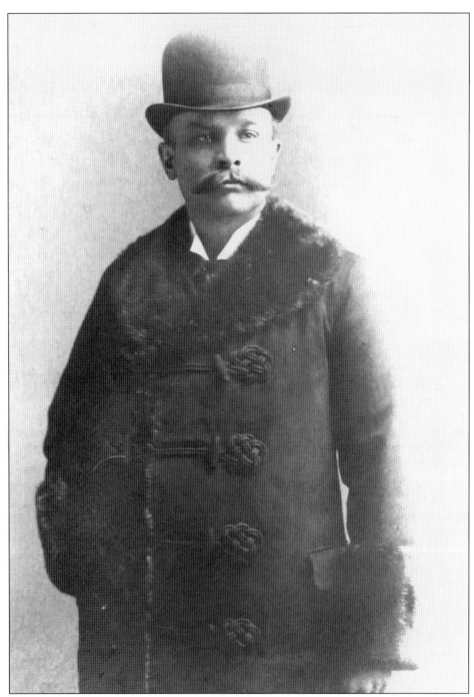

William DeLaBarre, an Austrian-born engineer, played a key role in managing waterpower at St. Anthony Falls for more than 40 years. Hired initially to handle engineering for the Minneapolis Mill Company, he would go on to serve as the manager for both the west-side Mill Company and the east-side St. Anthony Falls Company when the operations of both businesses were combined. DeLaBarre would help spur the development of hydroelectric power at the falls. (Courtesy of the Minnesota Historical Society.)

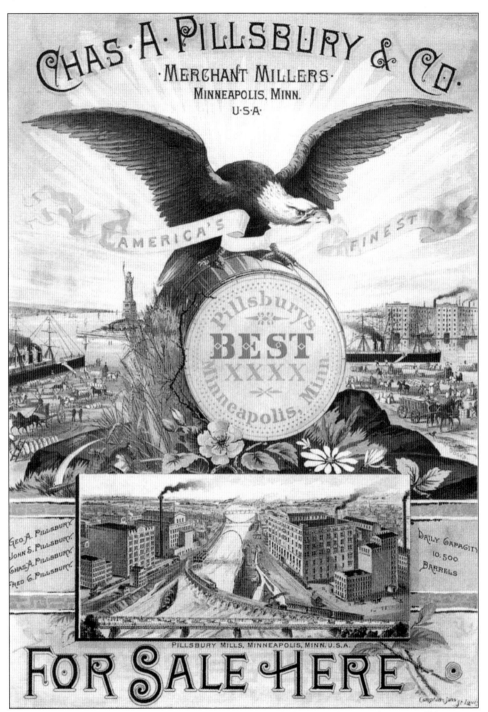

The firm founded by the Pillsbury family in 1872 branded its flagship product as Pillsbury's Best Flour. As the Minneapolis-based company expanded its marketing efforts, Pillsbury's Best became a nationally known brand. The Pillsbury Company continued to market its flagship brand until rival General Mills bought out the company in 2001. Pillsbury flour is now marketed by the Ohio-based J.M. Smucker Company. (Courtesy of the Mill City Museum.)

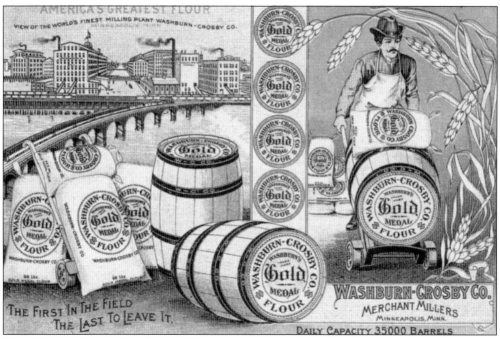

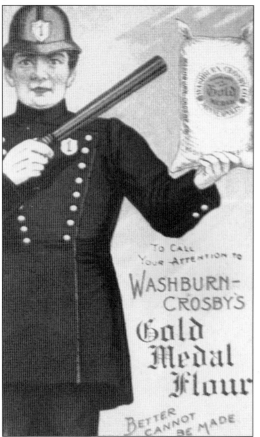

The Washburn Crosby Company, which later became General Mills, relied on marketing and advertising to sell the company's flour worldwide. Both of these ads were used to sell Washburn Crosby's Gold Medal flour. The top advertising card depicts St. Anthony Falls, the Stone Arch Bridge, and the west-side milling district. Gold Medal flour is still available on modern supermarket shelves. (Above, courtesy of Mill City Museum; at left, Hennepin County History Museum.)

James J. Hill built his Union Depot at the downtown riverfront five years after the construction of his Stone Arch Bridge. The depot served as a station for Hill's railroad until the Great Northern Depot replaced it in 1913. This 1890 photograph shows the Union Depot. (Courtesy of Hennepin County Public Library Special Collections.)

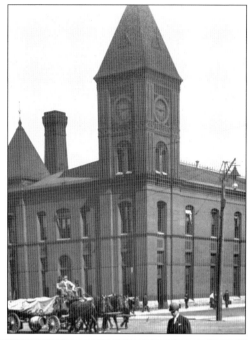

This train station was built for the Chicago, Milwaukee & St. Paul Railroad in 1899. Known as the Milwaukee Depot, the Renaissance Revival building was identified by its pinnacled clock tower, which became an early-20th-century landmark. The depot's large waiting room was embellished with a marble floor, arched doorways, and a decorative plaster ceiling. (Courtesy of Hennepin County Public Library Special Collections.)

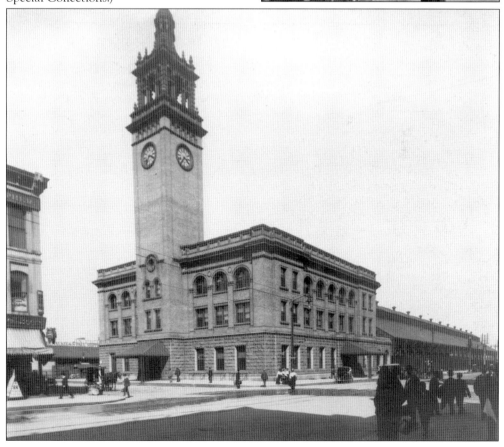

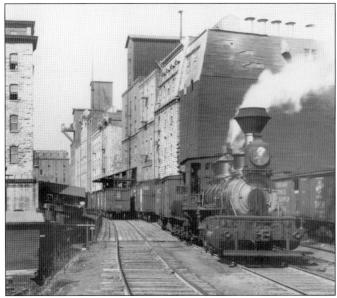

The 1880s was a decade of high growth for Minneapolis. By 1890, the city's population had reached 165,000, up from 47,000 in 1880, and it had surpassed St. Paul as Minnesota's largest urban center. The city's industry was concentrated in the milling adjacent to St. Anthony Falls. With flour constituting 75 percent of the city's industrial output, the falls continued to power Minneapolis's economic boom. (Courtesy of Hennepin County Public Library Special Collections.)

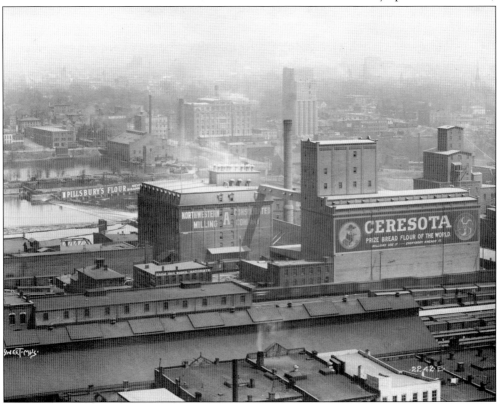

By the second decade of the 20th century, the city's milling industry was reaching its peak production. This photograph shows the large Ceresota advertising sign painted on the side of the Northwestern Consolidated Milling Company grain elevator. The sign was restored and retained when the structure was rebuilt as an office building in the 1990s. (Courtesy of Hennepin County Public Library Special Collections.)

Four

Beyond the City's Center

When Minneapolis received its corporate charter from the Minnesota Territorial Legislature in 1856, the tiny frontier settlement had established itself on the west bank of the Mississippi River at Saint Anthony Falls. At that time, the town's boundaries encompassed a stretch of the river extending for about a mile up and downstream from the falls. Over the next 75 years, a series of annexations added to the city's geography and expanded its riverfront.

In 1873, Minneapolis absorbed the village of St. Anthony and extended its jurisdiction to the river's east bank. In 1887, the city's boundaries were expanded again, giving Minneapolis a riverfront stretching for 12 miles.

Above the falls, the Minneapolis riverfront included little in the way of attractive natural features, and it soon filled in with a variety of industrial uses, including lumber mills and breweries. Below the falls, the river twisted and turned as it passed through steeply wooded banks on its journey south to the Gulf of Mexico.

While Minneapolis was undergoing a huge spurt in growth during the 1880s, noted American landscape architect H.W.S. Cleveland called for a plan to maximize the scenic potential of the river, the city's most dominant natural feature.

Just beyond the downtown riverfront, the Mississippi River swept around a bend and past a narrow strip of land that often flooded in the spring. This flood-prone strip became known as Bohemian Flats. It served as a port of entry for impoverished European immigrants up through the early decades of the 20th century.

On the bluffs across from the Bohemian Flats, the state's flagship institution of higher education, the University of Minnesota, took shape starting in the late 1850s. Farther downriver, on river bluff at the city's southern edge, the state's residence for retired veterans, originally known as the Old Soldiers Home, was established in 1887.

As the city's riverfront industries declined during the middle decades of the 20th century, the city turned its back on the river. Then, starting in the 1970s, a riverfront revival sought to capitalize on the Mississippi River's natural amenities as it meandered through the city of Minneapolis. Soon, an expanded system of parks and parkways was opening river vistas that had been obscured by decades of now-faded industrial development.

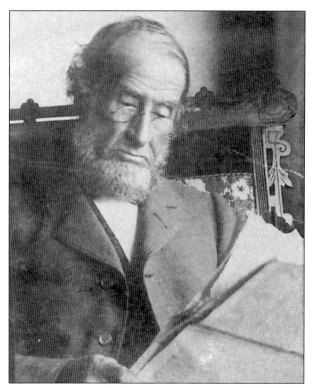

In 1883, landscape architect H.W.S. Cleveland told city officials, "The Mississippi River is the grand natural feature which gives character to your city. It should be placed in a setting worthy of so priceless a jewel." Cleveland proposed a series of parkways linking the river with the city's lake district. His plan, called the Grand Rounds, still provides a blueprint for the Minneapolis Park and Recreation Board in the 21st century. (At left, courtesy of the Ramsey County Historical Society; below, author's collection.)

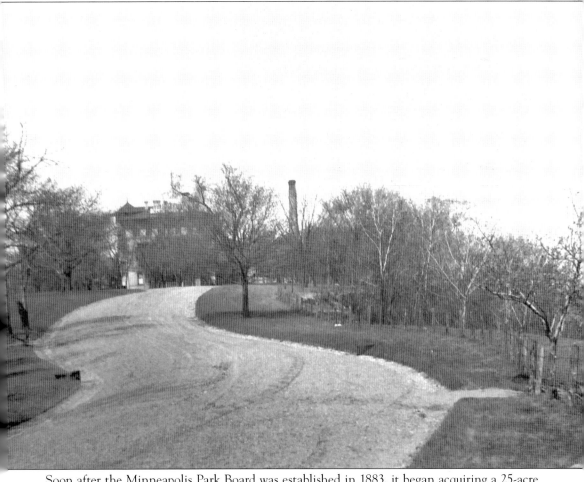

Soon after the Minneapolis Park Board was established in 1883, it began acquiring a 25-acre wooded site overlooking the Mississippi River, about a mile downstream from St. Anthony Falls. This early acquisition, now known as Riverside Park, provides a welcome stretch of green space adjacent to one of Minneapolis's inner-city neighborhoods. (Courtesy of Hennepin County Public Library Special Collections.)

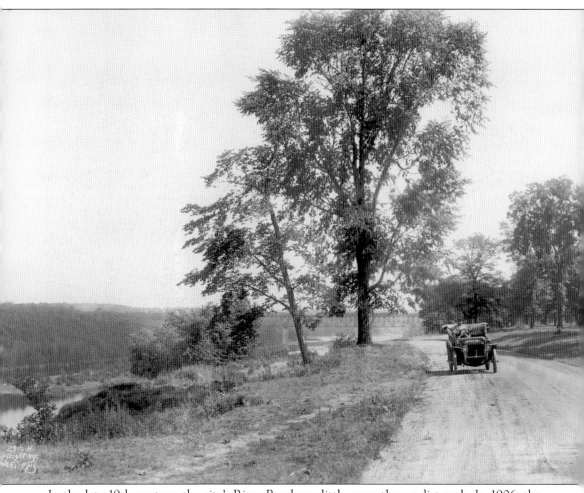

In the late 19th century, the city's River Road was little more than a dirt path. In 1906, the Minneapolis Park Board upgraded the road to a permanent parkway that became a popular motoring route. The newly improved parkway hugged the bluffs of the Mississippi as the river flowed through a steeply wooded gorge. (Courtesy of Hennepin County Public Library Special Collections.)

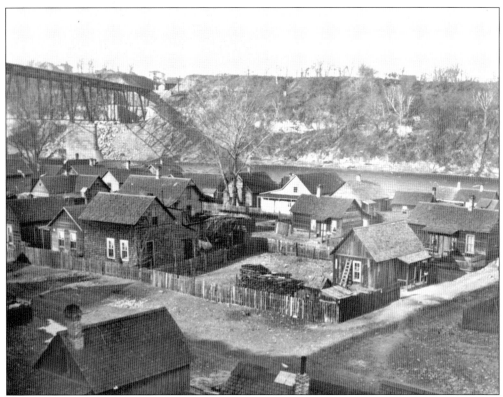

Bohemian Flats was the name given to a low-lying residential neighborhood on the west bank of the river, a half mile downstream from the downtown milling district. The flats served as a port of entry for impoverished immigrants, mainly from eastern and northern Europe, during the latter part of the 19th century. The district got its name from the large number of Czech emigrants from Bohemia who settled in the district. (Courtesy of Hennepin County Public Library Special Collections.)

Bohemian Flats residents often gathered up logs, mill ends, and stray pieces of lumber that floated downstream from the sawmills at St. Anthony Falls. They would build low piers out from the riverbank and used hooked poles to snag the lumber as it floated by. Some of the wood was used for household fuel, and the rest was sold to generate a small source of additional income for families. (Courtesy of Hennepin County Public Library Special Collections.)

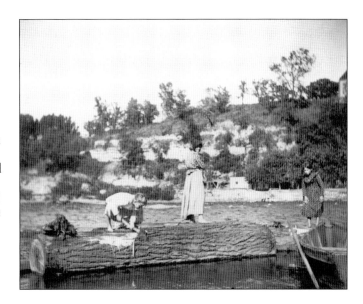

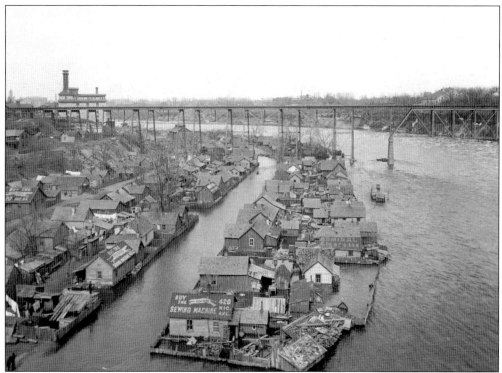

During the spring of the year, Bohemian Flats was subject to frequent flooding. One account of life on the flats noted, "As the ice went out, the river in its headlong rush would overflow its banks and the low-lying village was in its path." Residents would need to move quickly to evacuate themselves and their families to higher ground. (Courtesy of Hennepin County Public Library Special Collections.)

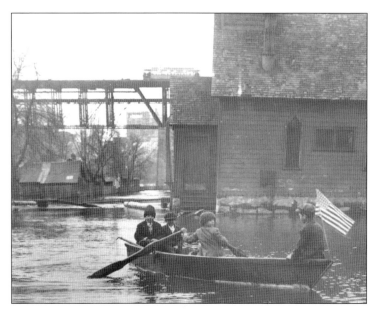

For the district's children, spring flooding was something of an adventure and a holiday. They stayed home from school and helped their families cope with the rising waters. But, there was also time to frolic in the flooded streets. During the flooding season, rowboats were the main method of transportation on Bohemian Flats. (Courtesy of Hennepin County Public Library Special Collections.)

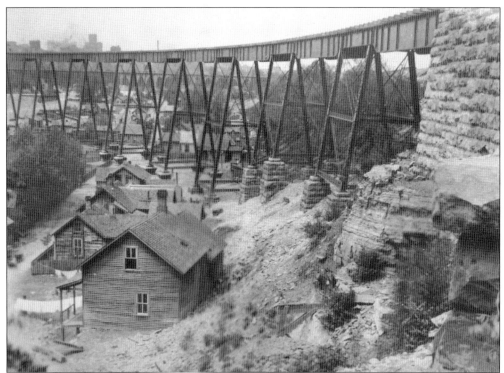

Residents lived in small frame homes, some little more than shacks that lacked indoor plumbing and other modern conveniences. Rents were cheap and affordable to new arrivals; many paid $15 to $25 a year for their tiny riverfront cottages. Starting in the 1930s, the city acquired and demolished the homes on Bohemian Flats and converted the area to an industrial district. (Courtesy of Hennepin County Public Library Special Collections.)

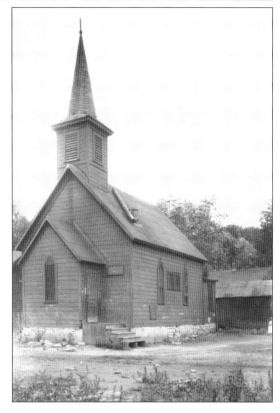

In 1888, thirty-six charter members organized St. Emmanuel Slovak Lutheran Church. The church served as a community-gathering place for Bohemian Flats residents during its early years. By 1908, the congregation had outgrown its modest building and relocated to a new site across the river in the university district. (Courtesy of Hennepin County Public Library Special Collections.)

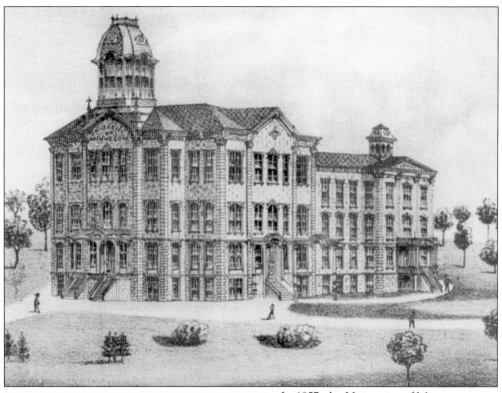

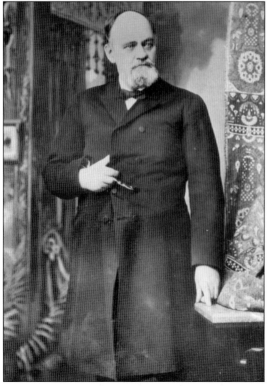

In 1857, the University of Minnesota built its first permanent building, Old Main, on an east-bank site, overlooking the Mississippi River downstream from St. Anthony Falls. But economic hard times and the Panic of the 1857 caused the school to close six months later. When the university reopened in 1868, Old Main served as the center of campus life until a fire destroyed the building in 1908. (Courtesy of Hennepin County Public Library Special Collections.)

John S. Pillsbury, one of St. Anthony's leading citizens, became an early benefactor of the university. As a university regent, Pillsbury was able to obtain land-grant status for the school under the terms of the federal Morrill Act. He played a key role in preserving the university and placing it on a firm financial footing during its early years. (Courtesy of the Minnesota Historical Society.)

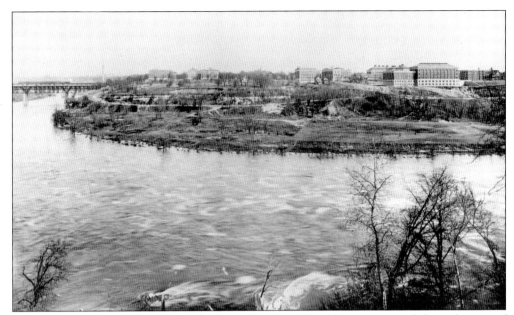

As the university expanded during the latter decades of the 19th century and the early years of the 20th century, the flats below the east-bank campus remained undeveloped. For a time, the flats served as parking lot for commuting students until it was reconfigured as a riverfront park. (Courtesy of Hennepin County Public Library Special Collections.)

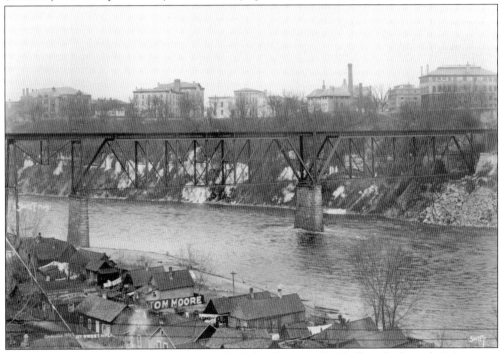

This photograph shows the university's east-bank buildings on the bluff overlooking the Mississippi River. Bohemian Flats was still occupied with small frame homes at the time this photograph was taken in the mid-1920s. The building at the far right, above the bridge, is Wulling Hall. It is still in use today. (Courtesy of Hennepin County Public Library Special Collections.)

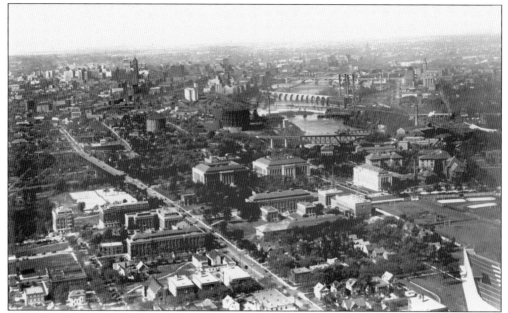

By the 1930s, the university's campus covered more than 300 acres, extending to the east bank of the river. The Northrop Mall, at the heart of the campus, was developed according to a plan prepared by famed American architect Cass Gilbert in 1908. The individual buildings flanking Northrop Mall were built later, starting in the 1920s. By the middle decades of the 20th century, the Northrop Mall had become the center of student life on campus. (Courtesy of Hennepin County Public Library Special Collections.)

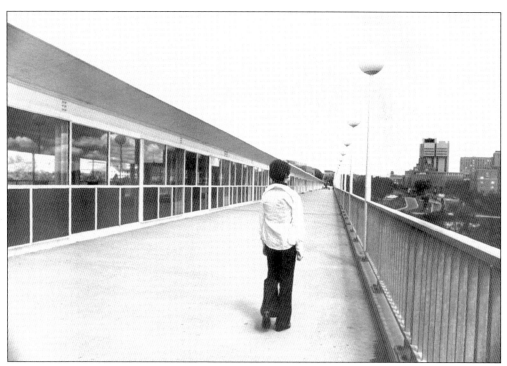

In 1965, a double-decked Washington Avenue Bridge replaced the original 1884 structure. The bottom deck was designed to carry automotive and bus traffic. The top deck was a walkway reserved for pedestrians and bicyclists. Initially, the walkway is merely a flat open space. In the 1970s, it was enclosed to protect students and university staff from the wind and rain as they travelled back and forth between the east-bank and west-bank campuses. (Courtesy of Hennepin County Public Library Special Collections.)

Starting in the 1960s, the university expanded to a new site on the west bank of the river. One architectural critic noted that the new campus posed its buildings "like giant sculptures in broad expanses of space." The west-bank campus replaced a portion of the historic Cedar Riverside neighborhood, home to newly arrived Northern European immigrants in the late 19th century. (Courtesy of Hennepin County Public Library Special Collections.)

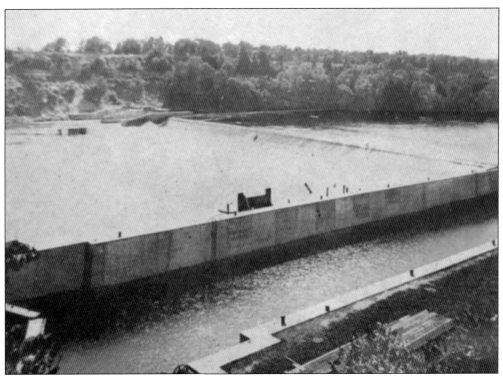

At the time it was built in 1907, the lock and dam at Meeker Island was intended to encourage river traffic beyond St. Paul. In 1917, a new, more substantial facility, known as Lock and Dam No. 1, built a half mile downstream, led to the abandonment of the Meeker Island Lock and Dam. Remnants of the 1907 navigation project were later incorporated in a historic park at the site. (Above, courtesy of the Minnesota Historical Society; below, author's collection.)

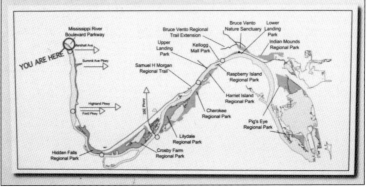

The Meeker Island Lock and Dam was the first lock and dam constructed on the Mississippi River between 1899 and 1907. The lock was in operation for 5 years, closing in 1912. The dam was then demolished. However, in low water conditions the 334 foot long concrete walls of the lock are still visible.

The Meeker Island Lock and Dam was added to the National Register of Historic Places in 2003.

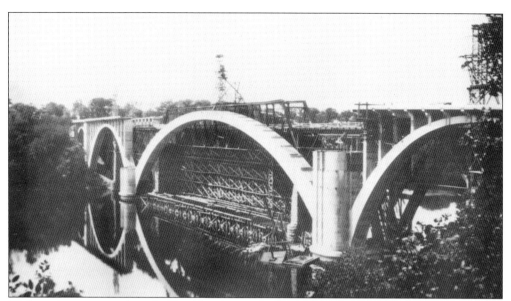

With its three giant arches, the Franklin Avenue Bridge, also known as the F.W. Cappelen Bridge, connects the Seward neighborhood on the west bank with the Prospect Park neighborhood on the east bank. The bridge was constructed between 1919 and 1923. It is named for Frederick William Cappelen, one of its builders, who died while the bridge was under construction. (Courtesy of Hennepin County Public Library Special Collections.)

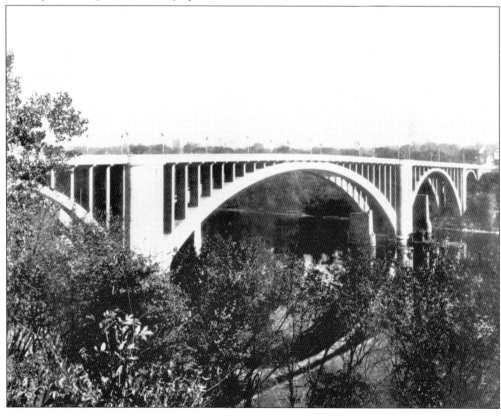

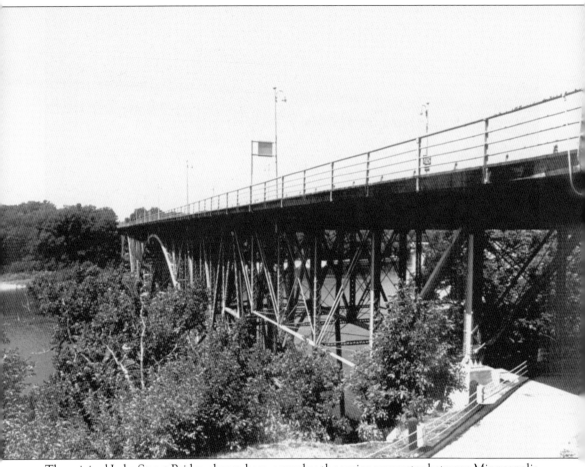

The original Lake Street Bridge, shown here, served as the major connector between Minneapolis and St. Paul when it was built in 1889. A new bridge replaced the earlier span in the early 1990s. While it was being built, one of the new spans collapsed, killing a construction worker. (Courtesy of Hennepin County Public Library Special Collections.)

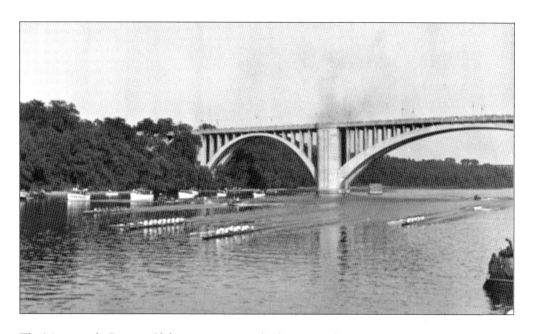

The Minneapolis Rowing Club traces its origins back to 1877 when 15 original members established a boating club at Lake Calhoun in South Minneapolis. After a hiatus lasting several decades in the 1950s and 1960s, the club resumed its activities when it erected an A-frame boathouse on the Mississippi River, just below the Lake Street Bridge. After the A-frame was destroyed by fire in 1997, it was replaced by a new, architecturally unique boathouse. The photograph above shows the US National Championship Races held on the river in 1941. (Courtesy of David Sheppard.)

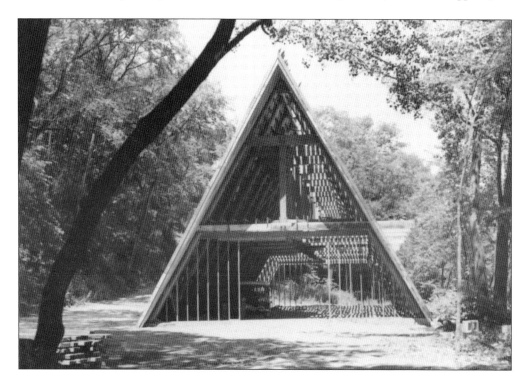

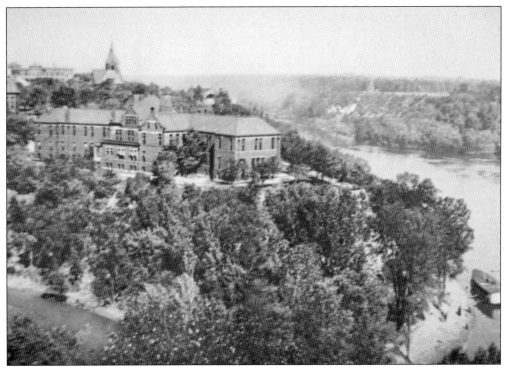

Originally known as the "Old Soldiers Home," the Minnesota Veterans Home was built on a 51-acre site overlooking the Mississippi River, adjacent to Minnehaha Falls Park. Construction of the initial group of eight buildings occurred between 1888 and 1892. H.W.S. Cleveland designed the overall plan for the river-view site. (Courtesy of the Minnesota Historical Society.)

The Minnesota Legislature authorized the establishment of the Minnesota Veterans Home in 1887 as a "reward to the brave and deserving" Civil War veterans. The mission of the state-run institution during its early years was to provide a pleasant living environment for veterans in recognition of their service to their country. Medical services were not provided until the 1920s. Later, the residential facility would start offering long-term care for indigent military veterans and their families. (Courtesy of the Minnesota Historical Society.)

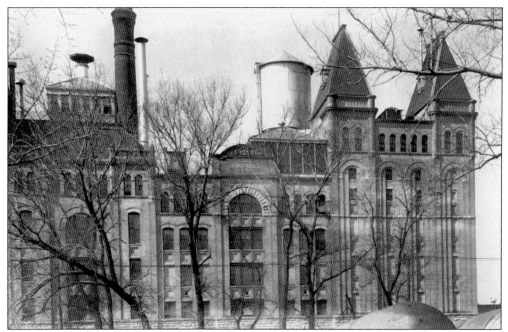

One of Minnesota's best-known brands, Grain Belt beer, was produced in this building, constructed in 1892 for a company originally known as the Minnesota Brewing Company. Later known as the Grain Belt Brewery, the massive structure overlooks the east bank of the river at Marshall Street in Northeast Minneapolis. One historian has described the building as "Northeast's greatest architectural monument, a Victorian storybook of a building that erupts at the roofline into a dance of towers, domes and cupolas." (Courtesy of Hennepin County Public Library Special Collections.)

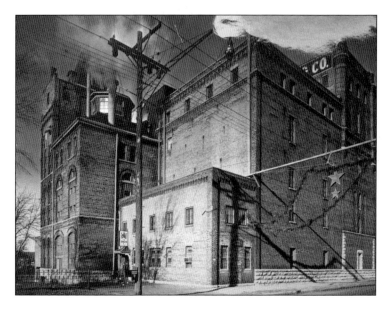

German immigrant Gottleib Gluek established Gluek Brewery. His brewery operated at a site on Marshall Street about a half mile north of the Grain Belt Brewery. Gluek Brewery closed in 1964, and the building was demolished in 1966. The riverfront site was later converted to a city park. (Courtesy of the Minnesota Historical Society.)

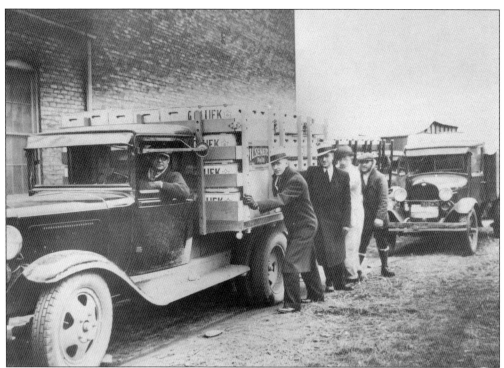

Prohibition forced Gluek to shut down its brewery in 1920. After a 13-year pause, Gluek resumed beer production when a federal act legalizing the sale of beer took effect on April 8, 1933. Delivery trucks were lined up outside the brewery during the early morning hours of April 8 waiting for the beer sales to begin. This happy customer purchased the first case of beer produced by Gluek when beer was legal once again. (Courtesy of the Minnesota Historical Society.)

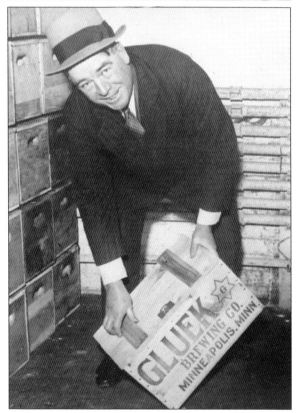

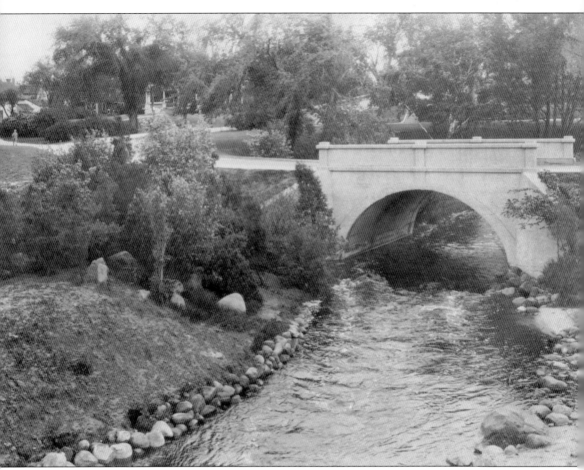

Shingle Creek flows through North Minneapolis near the city's northern boundary. The narrow waterway gets its name from a shingle mill built there in 1852. The creek cascades over a small waterfall just before it empties into the Mississippi River. (Courtesy of Hennepin County Public Library Special Collections.)

Five

THE LONG SLIDE

In 1904, the Minneapolis-based Washburn Crosby Company built a small flour mill in Buffalo, New York, on the shores of Lake Erie. That obscure development, just after the turn of the last century, helped launch a set of economic forces that would weaken, and eventually destroy, the Minneapolis milling industry. Within a few decades, as Buffalo achieved a substantial competitive advantage over its Midwestern rival, Minneapolis's flour mills began their slow downward slide.

The decline in milling coincided with a new role for the waterfalls that had propelled the city's economic growth, starting in the 1850s. As steam-powered manufacturing became increasingly important, the waterpower generated by St. Anthony Falls no longer served as the city's economic engine. In 1882, the country's first hydroelectric plant was established at the falls, marking the start of a new era that would bring electricity to the riverfront mills. In the mid-19th century, Minneapolis's business leaders had established their own industrial concerns to manage the waterpower generated by St. Anthony Falls. By the 1920s, these early companies had been absorbed by the region's major generator of electricity, then known as Northern States Power (NSP).

As the milling declined during the middle decades of the 20th century, many of the early mills were abandoned and several were demolished. The Washburn A mill, which anchored the west-side milling district, closed down in 1965, while the Pillsbury A Mill, across the river, continued operations on a limited basis until it was abandoned in the early 2000s.

The milling collapse infected the adjacent commercial districts, including Nicollet Island, which became filled with shabby hotels and seedy bars catering to the area's skid-row residents. City leaders made a series of concerted efforts aimed at halting the riverfront decline. These included a new post office, a gateway park, and a lock and dam at St. Anthony Falls, none of which were able to reverse the decline.

The once vibrant riverfront had become an area of desolation and decay in the 1950s. Soon, a burst of energy would breathe new life into this historic district, where the city had been born 100 years earlier.

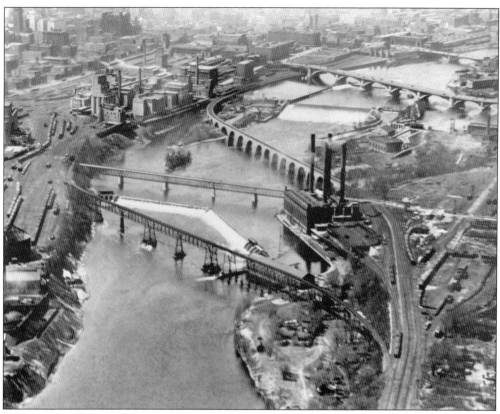

In the early 1920s, the Minneapolis riverfront was still a busting industrial district. But, flour production was already starting to decline from its high point during World War I. The rise of steam power, and later electric power, eroded the advantage that St. Anthony Falls provided in terms of waterpower. The local decline in milling was caused, at least in part, by railroad rate changes, which gave Eastern millers a competitive advantage over their counterparts in Minneapolis. (Courtesy of Hennepin County Public Library Special Collections.)

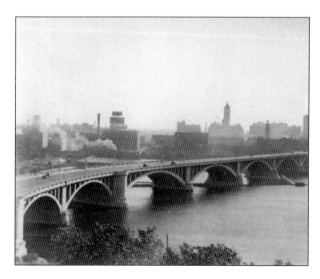

With the Minneapolis riverfront clogged with fading industrial buildings during the middle decades of the 20th century, the Third Avenue Bridge provided one of the few downtown sites that offered a view of the Mississippi River. The bridge, which opened in 1918, connected Third Avenue South on the west side with Central Avenue on the east side. Its curving configuration was designed to avoid fracturing the bedrock that supported the bridge piers. (Courtesy of Hennepin County Public Library Special Collections.)

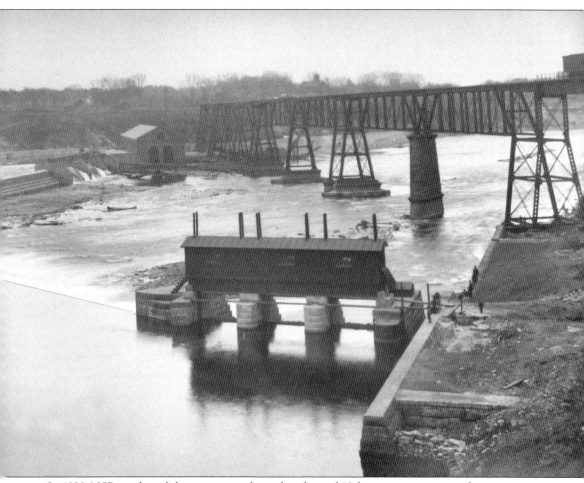
In 1923, NSP purchased the companies formed in the mid-19th century to manage the waterpower generated by St. Anthony Falls. Those early industrial firms, which had close connections to the riverfront flour mills, were now absorbed by NSP, a company in the business of generating electrical power. Electrical generation at the falls had its origins in the 1880s when the first hydroelectric facilities were established there. (Courtesy of the Minnesota Historical Society.)

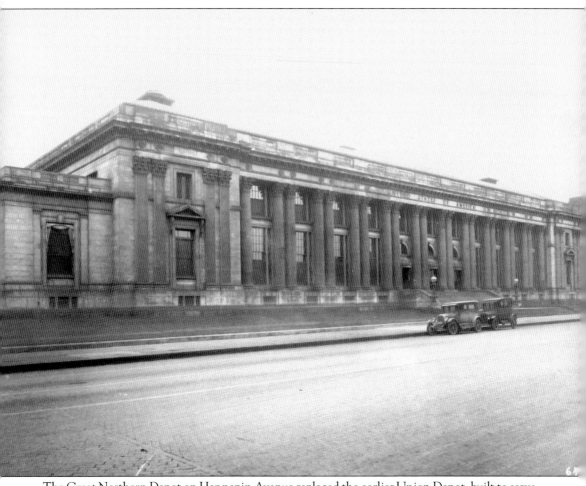

The Great Northern Depot on Hennepin Avenue replaced the earlier Union Depot, built to serve James J. Hill's railroad empire in the late 19th century. The Beaux Arts–style Great Northern, erected in 1913, represented another unsuccessful effort to revive the city's bleak Bridge Square District. The Great Northern Depot was demolished in 1978. (Courtesy of the Minnesota Historical Society.)

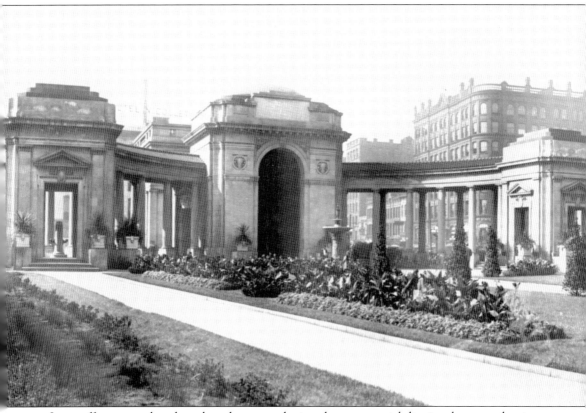

In an effort to combat the urban decay enveloping the commercial district closest to the river, Minneapolis created Gateway Park, its first urban renewal project, in 1908. But, the project was not a success. The park, with its classical pavilion and landscaped grounds, was little more than a besieged island in a sea of blight. The blocks facing it continued to be lined with bars and seedy hotels. Gateway Park was demolished in the 1950s. (Courtesy of Hennepin County Public Library Special Collections.)

Minneapolis, like other major urban centers, was hard hit by the Depression. Gateway Park, intended to uplift the surrounding commercial district, became a gathering place for unemployed men, many of whom struggled with alcoholism. Gateway denizens are seen below lounging in the park, directly across the street from the upscale Nicollet Hotel. (Courtesy of Hennepin County Public Library Special Collections.)

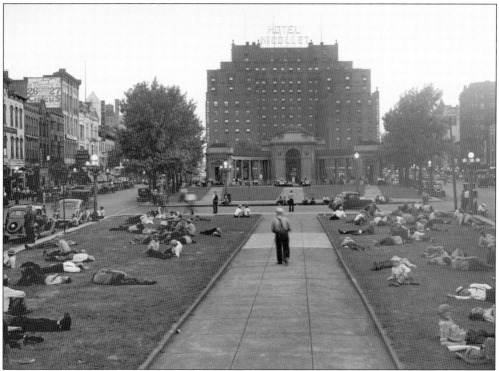

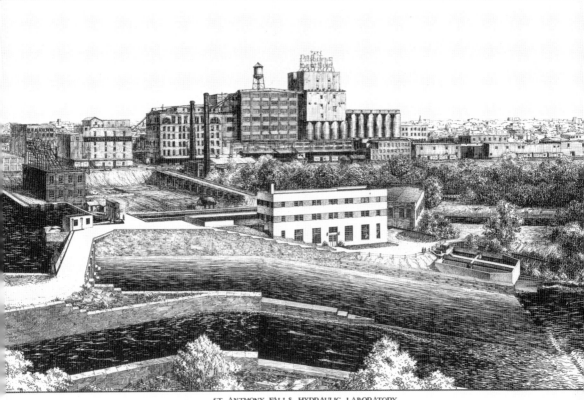

ST. ANTHONY FALLS HYDRAULIC LABORATORY
UNIVERSITY OF MINNESOTA
LORENZ G. STRAUB, CONSULTING ENGINEER
MINNEAPOLIS, MINNESOTA

One of the few new riverfront facilities built after the start of the milling industry decline, the University of Minnesota's St. Anthony Falls Laboratory opened in 1938. The laboratory, then part of the university's Department of Civil Engineering, was established as a center for hydraulics and river engineering research. The laboratory is the white building at the center of this illustration. St. Anthony Falls is depicted at the bottom of the drawing. (Courtesy of University of Minnesota Archives.)

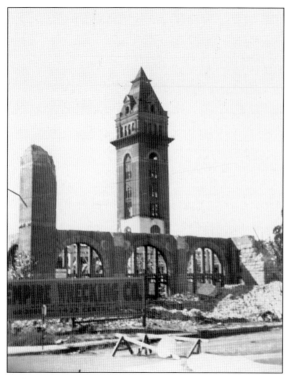

By the early decades of the 20th century, the Exposition Building had gone into a steep decline from its glory days as the site of the 1892 Republican National Convention. Never financially successful as an exposition center, the building was converted to a warehouse. Finally, in the early 1940s, the warehouse was demolished to make room for a Coca-Cola bottling plant. The Exposition Building tower, initially a prized landmark, later became an unwanted eyesore. (Courtesy of Hennepin County Public Library Special Collections.)

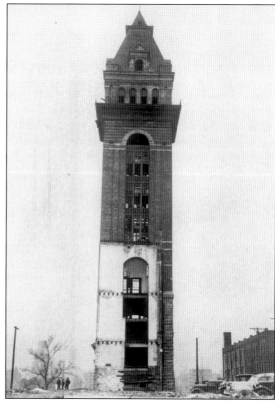

In 1942, the City of Minneapolis donated the scrap metal from its obsolete Tenth Avenue Bridge to the federal government to aid the war effort. Minneapolis mayor Marvin Kline (kneeling) is pointing to a sign that declares, "This bridge is Uncle Sam's!" The sign noted that the 460 tons of steel from the bridge would supply enough scrap to make 400 aerial bombs. (Courtesy of Hennepin County Public Library Special Collections.)

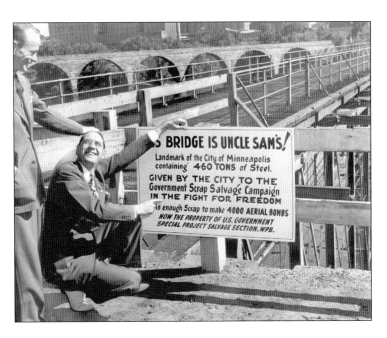

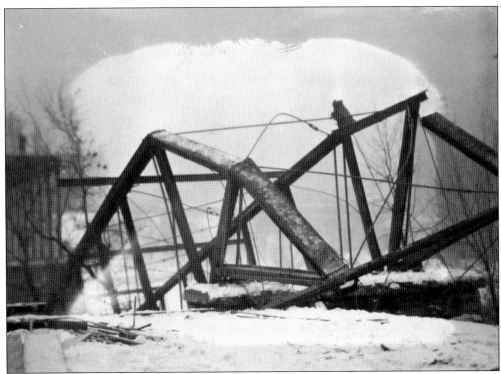

The drab 1870s-era metal-frame bridge provided a sharp contrast to the more elaborate Hennepin Avenue Bridge farther upstream. When the old bridge came down, its demise was not mourned. It was replaced by a concrete-and-steel span that connected what later became the University of Minnesota's west-bank campus with the Marcy Holmes neighborhood in Southeast Minneapolis. (Courtesy of Hennepin County Public Library Special Collections.)

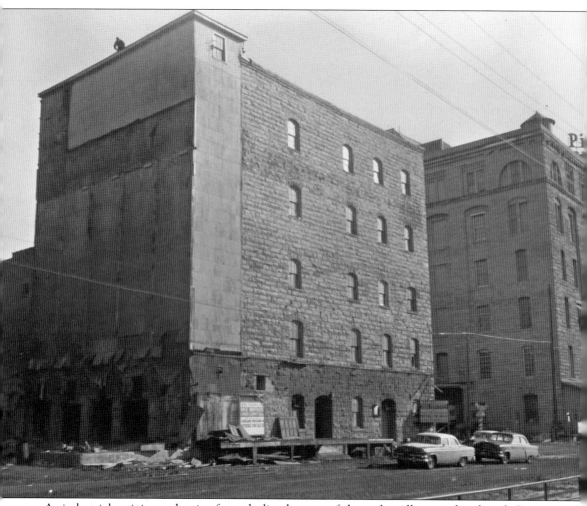

As industrial activity at the riverfront declined, many of the early mills were abandoned. One of the city's earliest mills, the Phoenix, adjacent to the Pillsbury A Mill, is shown here being demolished in the 1950s. When it was built in 1876, the *Minneapolis Tribune* called the Phoenix "a model of beauty, built on a foundation as solid as the everlasting hills." (Courtesy of the Minnesota Historical Society.)

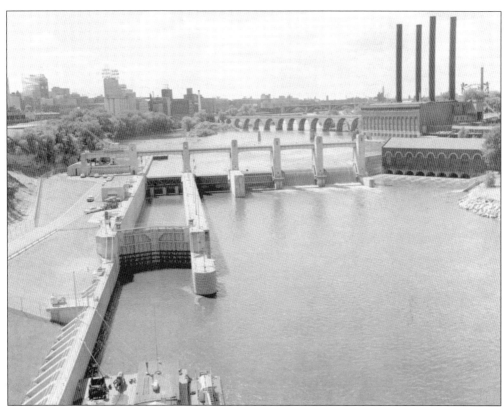

Even as the city's milling industry slowly faded away, community leaders realized a long-held civic dream to extend navigation on the Mississippi River above St. Anthony Falls. In 1963, after years of planning and politicking by the city's congressional delegation, the US Army Corps of Engineers finally completed the Upper Harbor Project. The project's locks enabled river navigators to bypass the falls. (Courtesy of Hennepin County Public Library Special Collections.)

Minnesota congressman Walter Judd was a prime mover in Washington, DC, for the Upper Harbor Project. "I don't know of any public works appropriation that I voted for that will bring as many public benefits as this one in 50 of 100 years," Judd declared during the project's dedication ceremony in September 1963. His prediction was never realized. The Upper Harbor did little to boost the local economy. (Courtesy of Hennepin County Public Library Special Collections.)

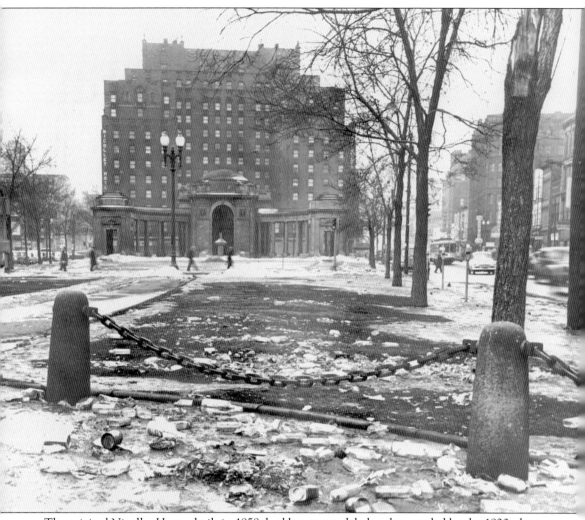

The original Nicollet House, built in 1858, had been remodeled and expanded by the 1920s, but the aged landmark had fallen on hard times. It was demolished in 1923 and replaced by a new Nicollet Hotel on the same site in 1924. While it attracted an upscale clientele, the Nicollet Hotel was surrounded by an increasingly decrepit Gateway District. After serving as a low-income residence for several years, the hotel was later abandoned and demolished in 1991. (Courtesy of Hennepin County Public Library Special Collections.)

In 1957, Minneapolis received the first in a series of federal urban-renewal grants aimed at converting the decaying lower downtown district into a modern Gateway Center. Federal funding for the ambitious urban-renewal project enabled the city to acquire and demolish blighted buildings in a 70-acre project area adjacent to the downtown riverfront. The Gateway Park Building (shown here) was demolished as part of the project. (Courtesy of the Minnesota Historical Society.)

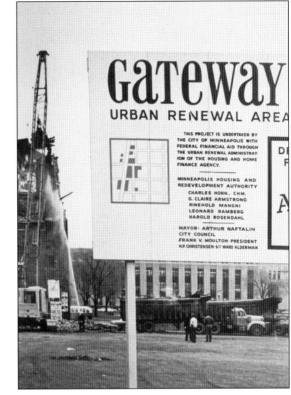

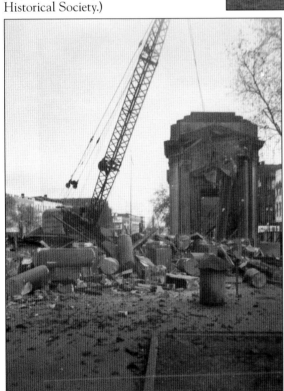

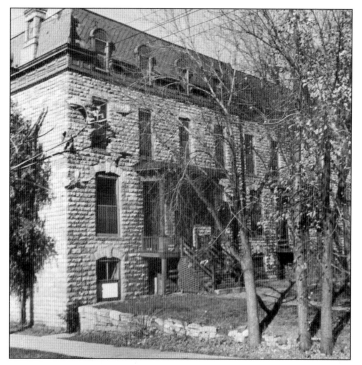

When it was built in 1877, Grove Street Flats was part of an upscale residential district on Nicollet Island. Designed in the French Second Empire style, the building contained eight townhouse units. As Nicollet Island lost its attractiveness to the city's well-to-do residents, Grove Street Flats became a shabby rooming house. The building was later abandoned. (Courtesy of Hennepin History Museum.)

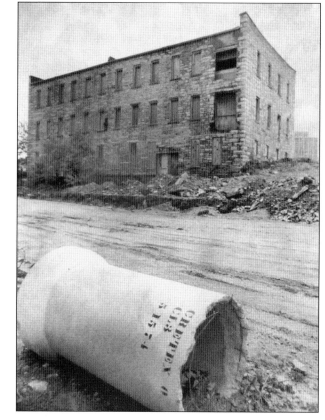

This abandoned building was built in the early 1890s for the Island Sash and Door Company. As Nicollet Island continued to decline during the mid-20th century, time and neglect took their toll on this once substantial limestone industrial building. (Courtesy of Hennepin History Museum.)

Six

THE NEW ERA

In 1962, Japanese immigrant Reiko Weston was looking for a new site for her popular downtown restaurant when she happened on St. Anthony Falls. "I saw this spot . . . and I was so sure this was the place," she later recalled. The spot was the site of the former Columbia flour mill. The farsighted entrepreneur would use the remnants of the mill as the foundation for her Fuji Ya restaurant, which opened six years later in 1968.

A year after the Fuji Ya opened at its new riverfront location, a young architect named Peter Nelson Hall purchased one of the aging storefront buildings across the river on the east bank's Main Street. The building known as the Pracna had been built in 1890 as a saloon. Later, it had been used a machine shop and warehouse.

With the help of a wealthy local businessman Louis Zelle, Hall was able to renovate the Pracna Building and convert it to a popular local restaurant. Hall's Pracna on Main launched an east-bank revival that would continue, in fits and starts, over the next 40 years.

Zelle would go on to build an ambitious mixed-use development, known as St. Anthony Main, adjacent to Pracna. St. Anthony Main was followed by an even more grandiose project, Riverplace, which planted high-rise apartment and condominium towers on the riverfront.

By now, city leaders had rediscovered the St. Anthony Falls District and were preparing elaborate plans to help guide the future development of the historic riverfront. But, development faltered in the late 1980s, as an over-built east bank succumbed to the vagaries of the local real estate market. St. Anthony Main and Riverplace failed as real estate ventures, causing at least a temporary setback in the late 20th-century riverfront revival.

On the west bank, a spectacular fire destroyed the Washburn A Mill in 1991. Later, an innovative museum would incorporate the mill remnants in its architecturally impressive structure. Through the 1990s, the Minneapolis Park Board would extend the river parkway down to the falls and uncover the ruins of early mills. Then, in 1994, the Stone Arch Bridge was converted to a pedestrian and bicycling pathway.

By the turn of the 20th century, the Mississippi riverfront was a focal point for Minneapolis once again, just as it had been 150 years earlier when the city was established on the banks of the river at St. Anthony Falls.

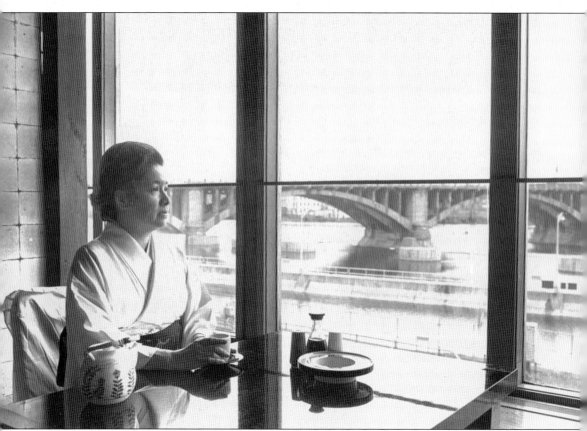

When Reiko Weston moved her Asian restaurant to the downtown riverfront, the area had been neglected for decades. Early visitors remember driving down a dimly lit gravel road to reach Weston's Fuji Ya. When they got there, they were rewarded with excellent Japanese cuisine and a spectacular view of the Mississippi River. Fuji Ya closed in 1990 when the Minneapolis Park Board acquired the property. (Courtesy of Carol Hanson.)

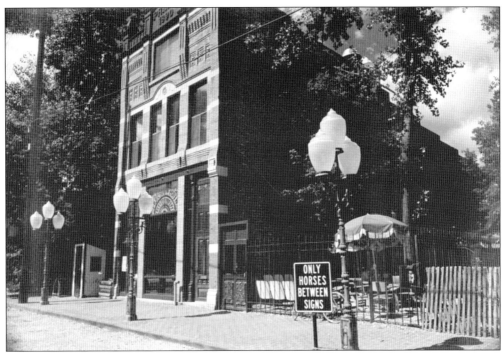

In the late 1960s, Peter Hall decided to purchase and renovate the small Victorian-era building on Main Street when the street was a dusty roadway lined with abandoned buildings. Hall's Pracna on Main would later become a popular east-bank gathering spot. Like the Fuji Ya restaurant across the river, Pracna helped launch a Minneapolis riverfront revival. (Above, courtesy of Hennepin County Library Special Collections; at right, Mill City Museum.)

St. Anthony Main, a mixed-use commercial project on the east-bank riverfront, opened in phases starting in 1977. The riverfront development was modeled after the successful Faneuil Hall complex in Boston, which used historical ambience as a magnet to attract visitors and shoppers. While St. Anthony Main was initially successful and brought new attention to the riverfront, the project ultimately failed as a commercial venture. (Author's collection.)

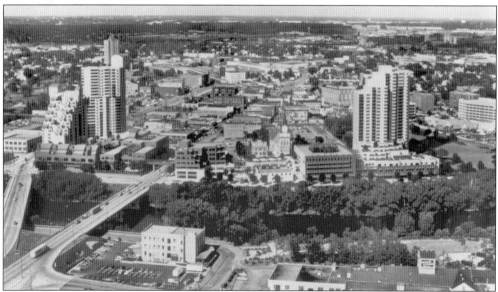

When it opened in 1984, the ambitious Riverplace project, with its mix of apartments, condos, and shops, spanned three blocks of historic Main Street. Promoters compared the massive project to San Francisco's Ghirardelli Square. Unfortunately, Riverplace never lived up to its hype. The project eventually failed, and the developer was forced to declare bankruptcy. Under new ownership, Riverplace's retail shops were converted to offices. (Courtesy of Hennepin County Public Library Special Collections.)

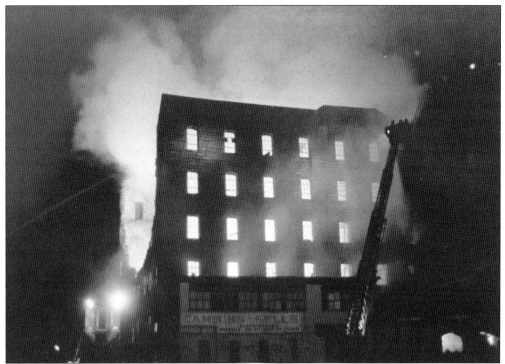

The Washburn Crosby A Mill, the site of the 1878 mill explosion, was a disaster scene 113 years later when the abandoned building burst into flames in 1991. The fire all but destroyed one of the state's most important historic sites. Thanks to the efforts of the Minnesota Historical Society's Nina Archabal, shown here, and Minneapolis City Council's Sharon Sayles Belton, a portion of the building's shell was saved even though its interior was destroyed. (Courtesy of the Minnesota Historical Society.)

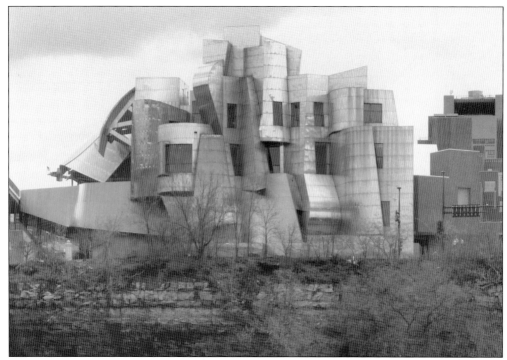

Internationally acclaimed architect Frank Gehry designed the Frederick R. Weisman Art Museum in 1993. The museum has been described as a "jolly jumble of colliding forms that face the Mississippi like a giant signboard." The east-bank building houses the University of Minnesota's extensive art collection, first assembled in 1934. (Author's collection.)

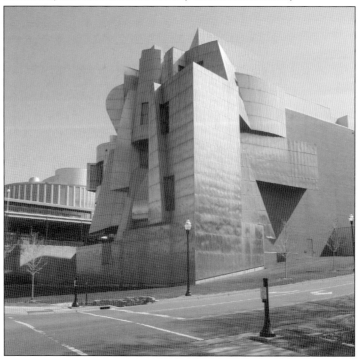

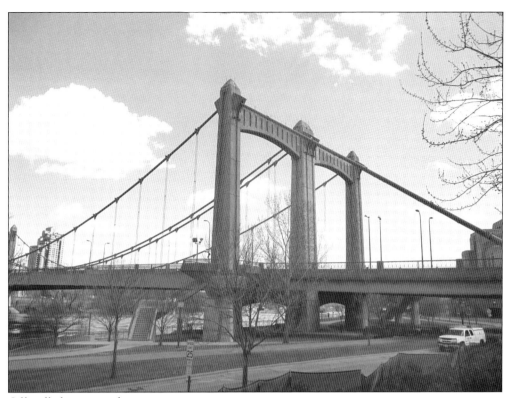

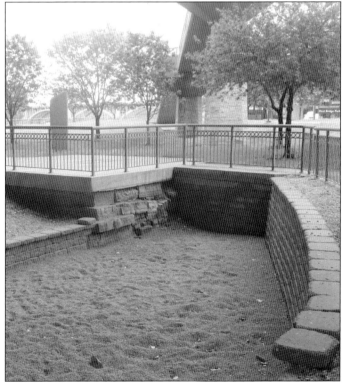

Officially known as the Father Louis Hennepin Bridge, the Hennepin Avenue Bridge honors the European explorer who discovered St. Anthony Falls in the 17th century. This current bridge, which opened in 1990, is intended to evoke the two earlier suspension bridges that spanned the Mississippi River at this site in the mid-19th century. The footings for the earlier bridges are preserved in First Bridge Park, located just under the Hennepin Avenue Bridge. (Author's collection.)

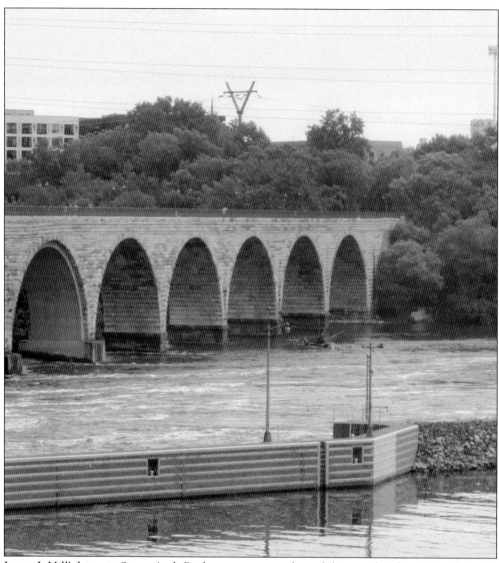
James J. Hill's historic Stone Arch Bridge was converted to a biking and pedestrian pathway in 1994. The bridge now connects Mill Ruins Park on the west bank with Father Hennepin Bluffs Park on east bank. The Stone Arch, along with the nearby Third Avenue and Hennepin Avenue bridges, gives visitors a chance to travel along a riverfront loop connecting the east and west banks. (Author's collection.)

Starting in the 1970s, the Minneapolis Park Board began making plans to extend the West River Parkway to the downtown riverfront. By combing a variety of state and federal funding sources, the park board was able to move the parkway along, building it in increments. Finally, in 1999, the board completed a key segment of the roadway, filling in the gap under the Interstate 35 West Mississippi River Bridge. (Courtesy of the City of Minneapolis.)

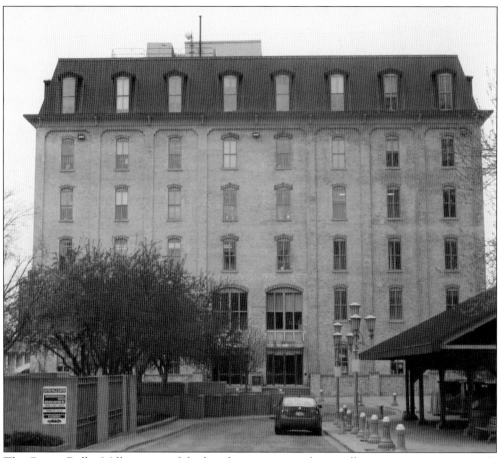

The Crown Roller Mill was one of the last downtown riverfront mills to remain in operation. It closed in the early 1950s. Then, in 1983, a fire virtually destroyed the vacant mill, leaving only a partial shell. The Crown's distinctive mansard roof was reconstructed, the mill's interior was gutted, and a new interior was built within the 19th-century shell. The nearby Ceresota, a former grain elevator, retained the distinctive Ceresota advertising sign when the structure was rebuilt as an office building. (Author's collection.)

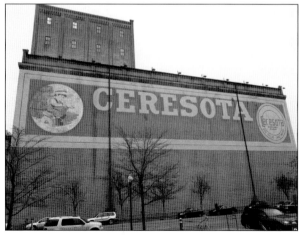

This low-rise residential development, known as Lourdes Square, was built on property initially slated for the massive Riverplace project. When Riverplace failed, Brighton Development received the development rights for the property and built the upscale brick townhouses named for the nearby Our Lady of Lourdes Church. (Author's collection.)

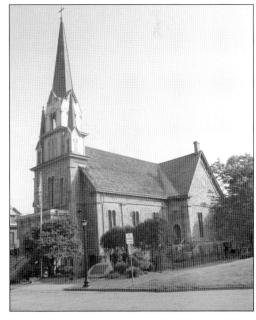

Under a plan developed for Nicollet Island in the 1980s, the south end of the island was preserved as a Minneapolis park while the aging but historically significant housing at the north end, adjacent to DeLaSalle High School, was retained and rehabilitated. Historic homes from other city neighborhoods were moved onto the island, creating a charming Victorian village in the middle of the Mississippi River. (Author's collection.)

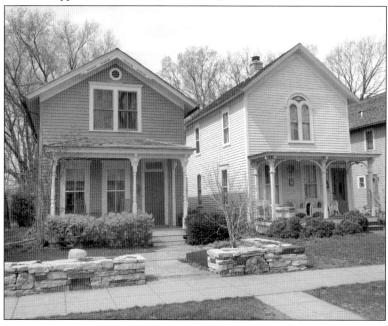

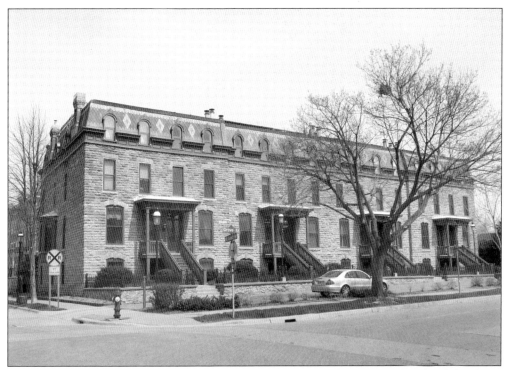

This Nicollet Island landmark was saved from the wrecking ball in 1982 when local developer John Kerwin rushed into a Minneapolis City Council meeting just as the council was about to approve a demolition permit for the abandoned building. Kerwin announced that he was prepared to redevelop the 1870s-era building. Now a 16-unit condominium, Grove Street Flats has brought back a touch of Victorian elegance to Nicollet Island. (Author's collection.)

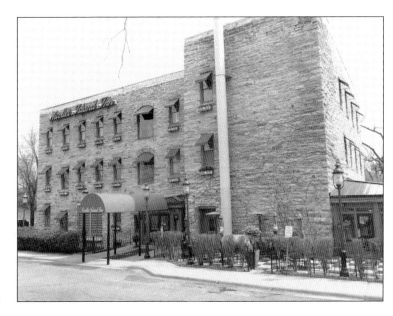

The Minneapolis Park Board acquired what was then an abandoned, decrepit building on Nicollet Island in the 1970s. The structure had originally been built for the Island Sash and Door Works in 1893. The building was renovated in 1982 and became a popular hotel and restaurant, the Nicollet Island Inn. (Author's collection.)

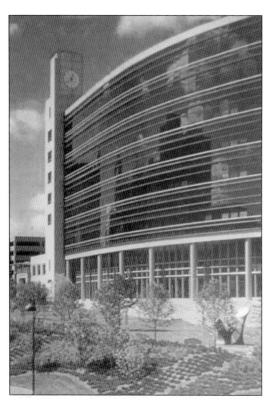

The Federal Reserve Bank of Minneapolis, built in 1997, is the home of the Ninth Federal Reserve District. The bank's prime riverfront location was formerly the site of the Great Northern Depot. While the building's tight security does not permit open public access, the bank's grounds have been designed to provide a public walkway down to the river. (Courtesy of the City of Minneapolis.)

In an effort to recognize the historical nature of its riverfront site, the Federal Reserve Bank created a series of sculptures that recall various eras in the history of the Minneapolis riverfront. This marker, "Gateway to the West," is intended to represent the early era in the city's history, from 1847 to 1870. During that span, the first suspension bridge across the river was built to connect the west bank with Nicollet Island and the east bank. (Author's collection.)

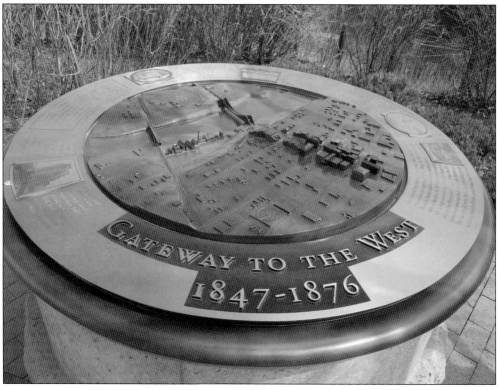

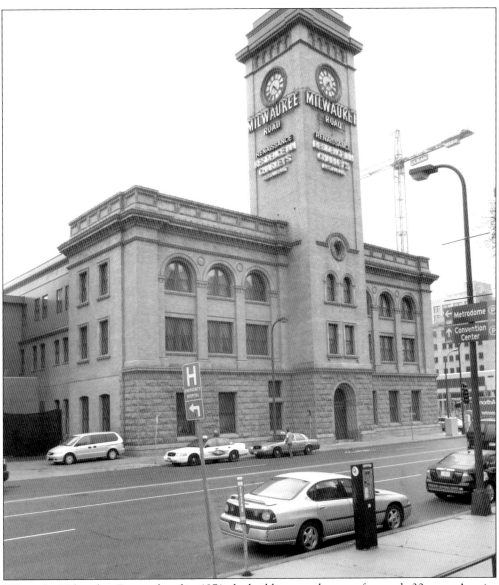

When the Milwaukee Depot closed in 1971, the building stood vacant for nearly 30 years. A series of developers tried to adapt the building for modern uses, but none succeeded until the CSM Corporation came up with a plan in the late 1990s to convert the depot to a hotel. The CSM project needed to conform to strict historic preservation guidelines that prohibited alternations, which would have changed the look of the building's facade. (Author's collection.)

The Milwaukee Depot's historic train shed created a dilemma for the depot's developer. The train shed was on the historic register, so its exterior could not be significantly altered, but the developer needed to find an economic use for the structure. The dilemma was solved when a large section of the train shed was reconstructed to house a skating rink. The remaining portion is used for parking. (Author's collection.)

Boom Island is no longer an actual island now that a river channel along the west bank has been eliminated. In the 19th century, the island was the center of the city's logging industry. The Minneapolis Park and Recreation Board began converting the site to a city park in the early 1980s. The park's lighthouse has become a popular local landmark. Boom Island Park offers a panoramic view of the downtown Minneapolis skyline. (Author's collection.)

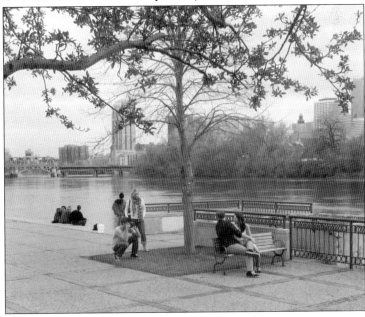

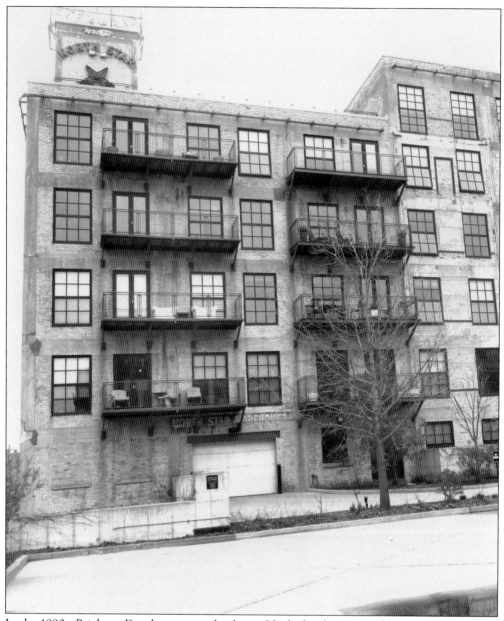

In the 1990s, Brighton Development took a leap of faith that buyers would come forward for its first west-side condominium project, the Northstar Lofts. "The area looked terrible. It felt like a wasteland," one of the Brighton partners later remembered. But the farsighted development firm soon found that it was attracting a steady stream of buyers who were able to look past the rubble to imagine what the riverfront could become. (Author's collection.)

Seven

The Riverfront in the 21st Century

The financial collapse of St. Anthony Main and Riverplace in the 1980s provided an opening for a small development firm that would soon make its mark on the riverfront. The firm, Brighton Development, had built and rehabilitated several low-rise east-bank projects that won high marks for their strong connections to the adjacent city neighborhoods.

In the late 1990s, Brighton turned its attention to the west bank, where abandoned mills littered the riverfront. The firm's leaders, attuned to the growing interest in historic preservation, decided to take a chance on rebuilding one of the mills, known as Northstar, and converting it to loft condominiums. When the Northstar Lofts proved to be a success, Brighton went on to develop other loft projects on the west bank, attracting buyers who were looking for an in-town experience in a historic setting.

The Brighton developments provided an enhanced environment for the new Mill City Museum, which interpreted the city's important milling history. The museum, which opened in 2003, incorporated the ruins of the Washburn Mill, which had been destroyed in 1991 fire.

In 2006, one of Minnesota's leading cultural institutions, the Guthrie Theater, built a dramatic new home on a riverfront site near the Mill City Museum. The new theater featured a cantilevered walkway, or bridge, extending out toward St. Anthony Falls.

Then, the next year, tragedy struck the riverfront when the Interstate 35 West Mississippi River Bridge collapsed, killing 13 people. The bridge was quickly rebuilt, and a memorial to the victims was installed on the river parkway, across from the new Gold Medal Park. The park was named for a popular brand of flour, produced by General Mills, the successor to the Washburn Crosby Company, whose mills had once anchored the riverfront's west bank.

Another new bridge, upstream from St. Anthony Falls, opened in 2012. The architecturally distinctive Lowry Bridge, with its tied-arch construction, provided an important new landmark in an industrial district just beginning to benefit from the city's riverfront revival.

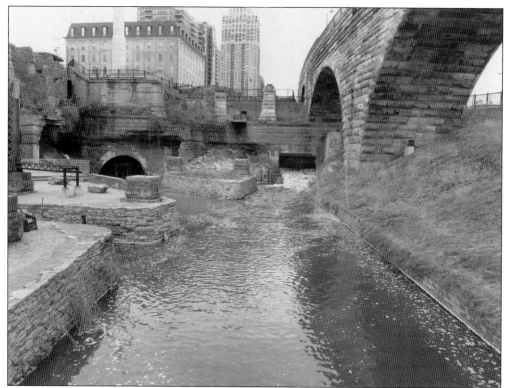

The ruins of an early section of the west-side milling district were uncovered in 2001 as part of an ongoing riverfront restoration effort. For years, this historic site was buried under tons of soil and debris. The excavated ruins uncovered walls, foundations, and tunnels extending back to the mid-19th century. They were part of a complex of mills served by a canal, which diverted a portion of the river flow and plunged it down over turbines that powered the milling machinery. The water from the canal was returned to the river through a channel known as a tailrace. The reconstructed tailrace is now the central feature of Mill Ruins Park, an archeological installation operated by the Minneapolis Park Board. (Author's collection.)

One of the city's most unique structures, the Mill City Museum, incorporates the ruins of the historic Washburn Crosby A Mill in a modern interpretive center. The museum, which opened in 2003, recalls Minneapolis's early riverfront history, with a special emphasis on flour milling and other local industries powered by St. Anthony Falls. One of the museum's most popular exhibits, the Flour Tower, is a multimedia show set in a freight elevator. The tower helps visitors experience the sights, sounds, and energy of the flour-milling process. Museum visitors can view "Minneapolis in 19 minutes flat," a lighthearted look at Minneapolis history, using photographs, video clips, and movies. (At right, Mill City Museum; below, author's collection.)

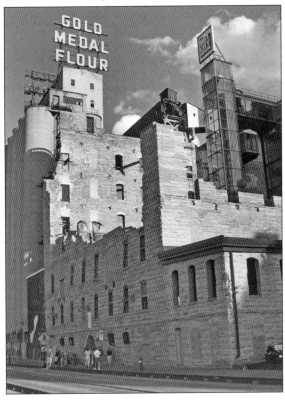

Interactive exhibits are popular with school groups that tour the museum on a regular basis. Children are able to get hands-on experience that makes the city's riverfront history more meaningful to them. These photographs show young people spinning a turbine and experimenting with waterpower. (Courtesy of Mill City Museum.)

The museum's courtyard has retained the ruins from the 1991 Washburn A Mill fire. The twisted metal girders and empty window openings help to convey the impact of the fire that devastated one of Minnesota's most important historic landmarks. An interpretive plaque inside the museum notes that the courtyard is "open to the sky and open to the imagination." During the summer months, the courtyard serves as a venue for Mill City Live, which brings music and entertainment to the downtown riverfront. (At right, Author's collection; below, Mill City Museum.)

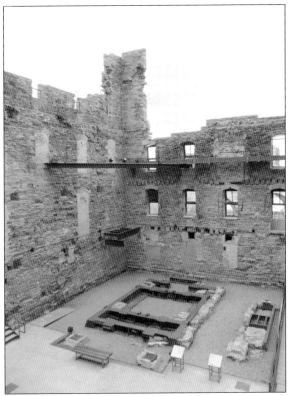

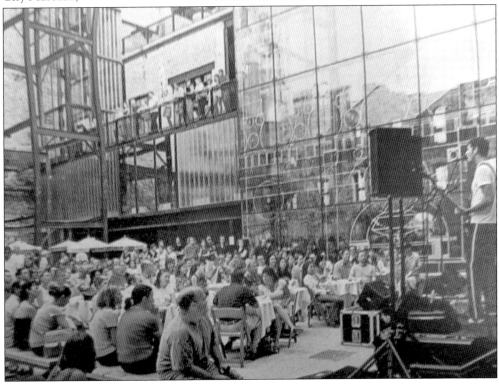

The Mill City Farmers Market operates an outdoor market on Saturday mornings from May through October. The market is located on the plaza between the Mill City Museum and the Guthrie Theater. This popular community-gathering place offers fresh produce, specialty foods, arts and crafts, and live music. During the colder months, the Mill City group sponsors an indoor market in the Mill City Museum on the second Saturday morning of each month from 10:00 a.m. to 1:00 p.m. (Courtesy of Mill City Museum.)

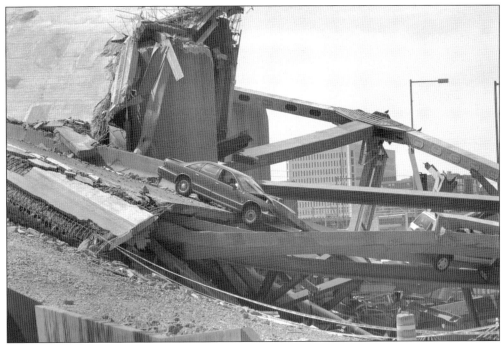

On the evening of August 1, 2007, the Interstate 35 West Mississippi River Bridge collapsed, killing 13 people and injuring 120 others. At the time of the collapse, the Interstate 35 Bridge was one of the most heavily travelled river crossings in Minnesota, carrying 140,000 vehicles daily. The National Transportation Safety Board later determined that design flaws and heavy traffic on the bridge probably caused the disaster during the evening rush hour. (Courtesy of Minnesota Historical Society.)

Almost immediately, disaster relief teams were at the site, ready to assist with rescue operations. Only a few vehicles were submerged in the river, but many motorists were stranded on the sections of the bridge that had collapsed. The injured were rushed to nearby hospitals, including the Hennepin County and Fairview medical centers. (Courtesy of Mill City Museum.)

113

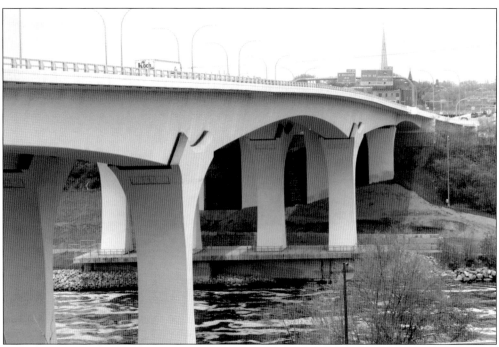

Soon after the Interstate 35 Bridge collapsed, highway officials began making plans for its replacement. The new bridge opened in September 2009, well ahead of schedule. The new 10-lane bridge was built with high-strength concrete and a series of sensors that measure bridge conditions, such as desk movement, stress, and temperature. A sculpture on the bridge deck resembles the symbol used on maps for water. At night, the bridge is illuminated with multicolored decorative lighting. (Author's collection.)

The Interstate 35 Bridge memorial is part of the Remembrance Garden, built in 2011 to honor the survivors and the victims of the bridge collapse. The memorial includes 13 pillars listing the names of the 13 people who died during the 2007 disaster. An inscription on the wall behind the pillar reads: "Our lives are not only determined by what happens, but how we act in the face of it, not only what life brings us, but what we bring to life. Selfless actions and compassion create enduring community out of tragic events." (Author's collection.)

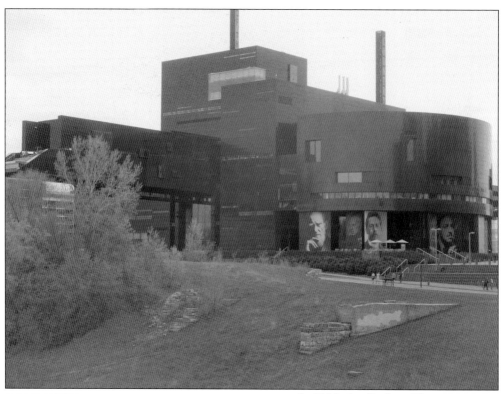

In 2006, the Guthrie Theater completed a new $125 million performance center on the downtown riverfront. French architect Jean Nouvel designed the building. It replaced the original theater on Vineland Place, built in 1963. At its new location, the Guthrie's most prominent feature is a 178-foot-long cantilevered extension, known as the endless bridge. With its observation platform overlooking the Mississippi River, the bridge has become one of Minneapolis's most popular tourist attractions. (Author's collection.)

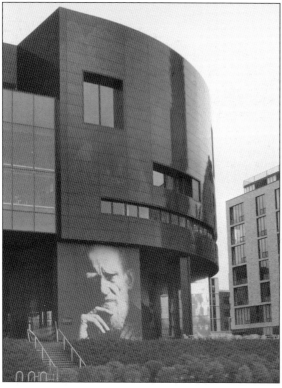

The theater's ground-level facade is decorated with images of prominent international dramatists. English playwright George Bernard Shaw is shown here. Shaw's plays are always a popular draw. His works have been performed frequently at the Guthrie. (Author's collection.)

This seven-acre park next to the Guthrie Theater takes its inspiration from the Indian burial mounds scattered throughout the Upper Midwest. The park consists of a spiral walkway leading up to a 32-foot-high mound. Visitors who make their way to the top of the mound are rewarded with a commanding view of the downtown riverfront. The park takes its name from the best-known brand, Gold Medal Flour, produced by the Washburn Crosby Company (later General Mills) whose production facilities were located nearby. (Author's collection.)

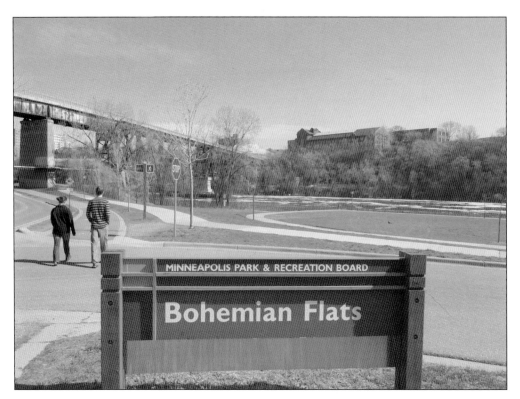

Once a port of entry for impoverished European immigrants, Bohemian Flats is now a grassy park extending down to the riverfront, just below the University of Minnesota's west-bank campus. The bridge shown in the photograph above once towered over the modest frame homes crowded on to the flats. Paradise Charter Cruises anchors its river cruise boats at Bohemian Flats Park. (Author's collection.)

The Washington Avenue Bridge contains two decks: the lower level is used for vehicular traffic and the upper level includes a walkway reserved for pedestrians and bicyclists. The bridge connects the east-bank and west-bank campuses of the University of Minnesota. The lower deck also includes the tracks for the Green Line, a light-rail transit project that began operating in 2014. The Green Line links downtown Minneapolis with downtown St. Paul. (Author's collection.)

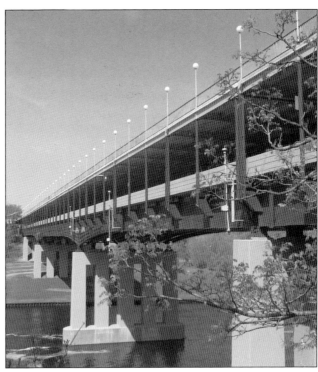

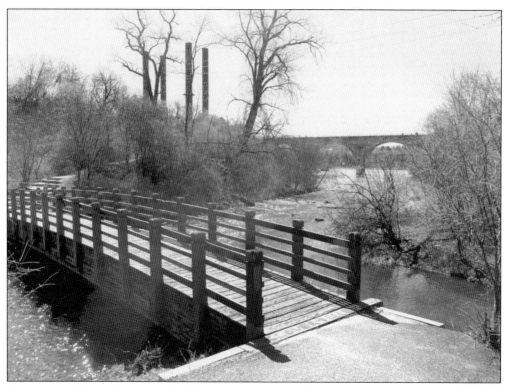

The six-acre Father Hennepin Bluffs Park covers the wooded riverbank just below the Pillsbury A Mill. The park is crisscrossed with wooden steps leading down to the river. A portion of this historic site is named for Philip Pillsbury, whose ancestors established the company that bears the family name. In 1981, the Pillsbury Company donated 2.1 acres of land to expand Father Hennepin Bluff Park. (Author's collection.)

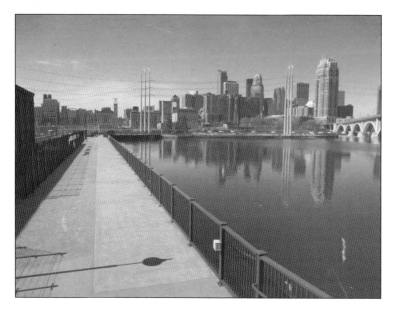

Water Power Park extends out into the Mississippi River on a narrow spit of land that was created when one of the river channels was filled in with soil. The park enables visitors to get a close-up view of St. Anthony Falls. The site is managed and maintained by the Minneapolis Park Board on property owned by Xcel Energy Company. (Author's collection.)

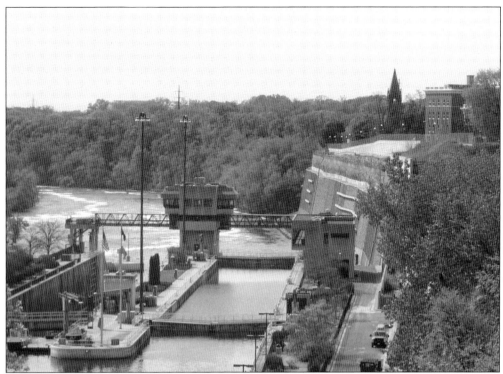

Lock and Dam No. 1, located just below the Minnesota Veterans Home, has been a Mississippi River landmark ever since it opened in 1917. Originally intended to ease commercial traffic to and from Minneapolis's flour-milling center, this river-navigation facility is now used mainly by pleasure crafts. The dam portion of Lock and Dam No. 1 was previously owned by Ford Motor Company, which used it to generate hydroelectric power for its St. Paul manufacturing facility that closed in 2011. In 2007, the hydroelectric plant was sold to Brookfield Power. (Author's collection.)

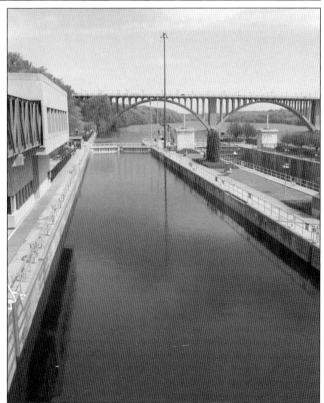

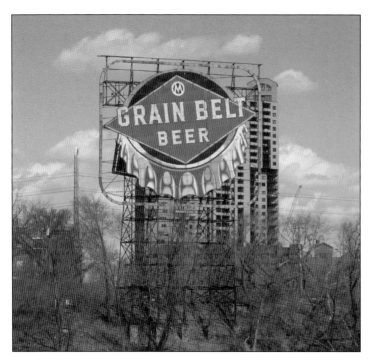

The Grain Belt Beer sign advertises what was once Northeast Minneapolis's best-known product. The sign, located on Nicollet Island, is in the form of a giant beer cap. The beer was manufactured at the Grain Belt Brewery about a mile upstream from the island. Now that the Grain Belt Brewery is closed, the beer is no longer produced in Minneapolis. A brewery in New Ulm, Minnesota, currently owns the Grain Belt brand. (Author's collection.)

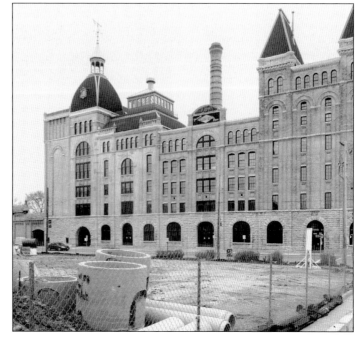

RSP Architects purchased the vacant Grain Belt Brewery Building and extensively overhauled the historic structure in 2002. The architectural firm preserved the brewery's facade and built an ultra-modern office and studio suite within the shell of the 1892 building. The adjoining brewery wagon shed has been rebuilt as a neighborhood library. The bottling house, next to the main brewery building, has been converted to artist studios. (Author's collection.)

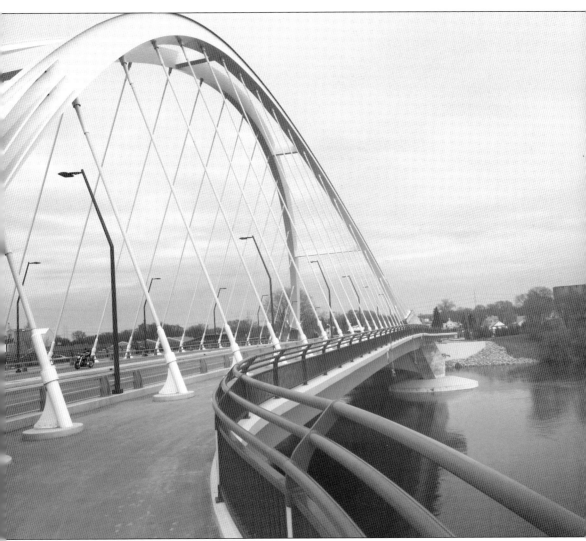

The Lowry Avenue Bridge was completed in 2012. It replaces earlier bridges at the same site, dating back to 1905. The new bridge provides a river crossing for Lowy Avenue, which connects North Minneapolis neighborhoods with those in Northeast Minneapolis. The new bridge makes use of a dramatic design known as basket-handled, tied-arch construction. Now an important new landmark, the Lowry Avenue Bridge is bringing renewed attention to a district known as Above the Falls. (Author's collection.)

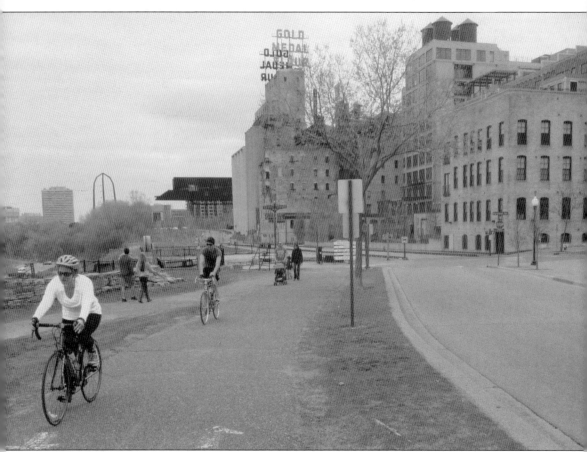

The bike path along the West River Parkway connects with more than 40 miles of off-road bicycle trails in the Minneapolis area. In 2011, the final one-mile link in the trail system through the city's downtown warehouse district connected the River Parkway with the Cedar Lake Trail that extends out to Minneapolis's western suburbs. Increasingly, bicycle commuters use the trails, even during the winter months. (Author's collection.)

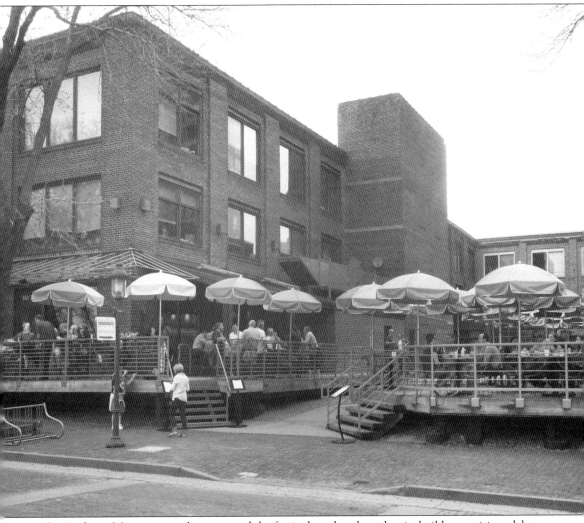

St. Anthony Main may not have created the festival marketplace that its builders envisioned, but the 1970s development continues to draw visitors to the east-bank riverfront. As a result, Main Street, once a dusty industrial back road, has been revived as the center of a vibrant new urban neighborhood. The district is experiencing a building boom, bringing hundreds of new housing units to the Minneapolis riverfront. (Author's collection.)

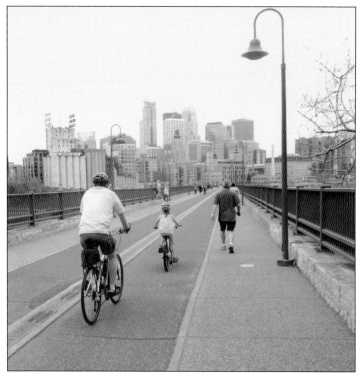

A major landmark when it was built 1883, the Stone Arch Bridge has been reborn as a recreational site and the symbol of Minneapolis's riverfront revival. As the spray from St. Anthony Falls splashes up on the bridge deck, visitors can experience the power of the raging cataract that played such a major role in the establishment of this Midwestern city more than 150 years ago. (Author's collection.)

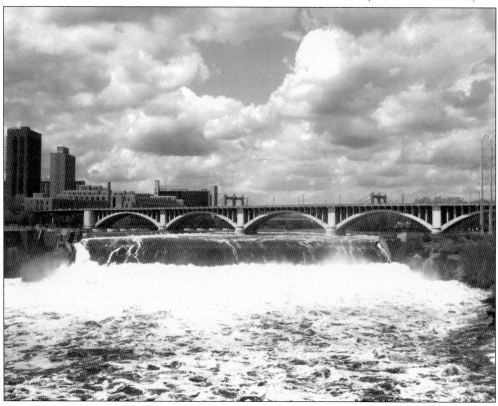

BIBLIOGRAPHY

Cunningham Group. *The Minneapolis Riverfront: Vision and Implementation*. Minneapolis: 1996.
Hage, Christopher, and Rushika Hage. *Nicollet Island: History and Architecture*. Minneapolis: Nodin Press, 2010.
Kane, Lucile. *The Falls of St. Anthony: The Waterfall That Built Minneapolis*. St. Paul, MN: Minnesota Historical Society Press, 1987.
Millett, Larry. *AIA Guide to the Twin Cities, St. Paul, MN*. St. Paul, MN: Minnesota Historical Society Press, 2007.
Minneapolis Planning Department. *Mississippi/Minneapolis: A Plan and Program for Development*. 1972.
Nathanson, Iric. *Minneapolis in the Twentieth Century: The Growth of an American City*. St. Paul, MN: Minnesota Historical Society Press, 2010.
Pennefeather, Shannon. *Mill City: A Visual History of the Minneapolis Mill District*. St. Paul, MN: Minnesota Historical Society Press, 2003.
Saint Anthony Falls Rediscover. Minneapolis: Minneapolis Riverfront Development Coordination Board, 1980.
"St. Anthony Falls, Making Minneapolis the Mill City." *Minnesota History*, Spring-Summer (2003): 250–331.
Works Progress Administration. *Bohemian Flats*. Minneapolis: University of Minnesota Press, 1941.

DISCOVER THOUSANDS OF LOCAL HISTORY BOOKS FEATURING MILLIONS OF VINTAGE IMAGES

Arcadia Publishing, the leading local history publisher in the United States, is committed to making history accessible and meaningful through publishing books that celebrate and preserve the heritage of America's people and places.

Find more books like this at
www.arcadiapublishing.com

Search for your hometown history, your old stomping grounds, and even your favorite sports team.

Consistent with our mission to preserve history on a local level, this book was printed in South Carolina on American-made paper and manufactured entirely in the United States. Products carrying the accredited Forest Stewardship Council (FSC) label are printed on 100 percent FSC-certified paper.